Botanical Prints
from the
Hortus Eystettensis

Botanical Prints from the Hortus Eystettensis

Selections from the most beautiful
botanical book in the world

Introduction by Nicolas Barker

with scientific commentaries by Gérard G. Aymonin

HARRY N. ABRAMS, INC., PUBLISHERS

Editor: Ruth A. Peltason
Designer: Dirk Luykx

Adapted from *Hortus Eystettensis: The Bishop's Garden and Besler's Magnificent Book* by Nicolas
Barker, first published in 1994 by The British Library, London, and by Harry N. Abrams,
Inc., New York. Scientific commentaries by Gérard A. Aymonin adapted from *The Besler
Florilegium: Plants of the Four Seasons,* first published in 1987 by Editio Citadelles, Paris, and
in 1989 by Harry N. Abrams, Inc., New York

Library of Congress Catalog Card Number: 99–67721
ISBN 0–8109–2743–8

Published in 2000 by Harry N. Abrams, Incorporated, New York

Printed and bound in Japan

Harry N. Abrams, Inc.
100 Fifth Avenue
New York, N.Y. 10011
www.abramsbooks.com

CONTENTS

INTRODUCTION

A Brief History of the Hortus Eystettensis

At the end of the sixteenth century, Johann Conrad von Gemmingen became Bishop of Eichstätt, in southern Germany. It was one of the oldest bishoprics in Germany, and its new bishop came of an ancient noble family. His own wealth and that of his see made him immensely rich. He set about his episcopal duties with considerable vigor, including the improvement of churches and their furniture. But his most substantial project was the modernization and rebuilding of the great palace on top of the hill that dominates the city of Eichstätt beneath, both encircled by the river Altmühl.

A major part of the Bishop's plan was the garden that surrounded and even invaded the palace. It consisted of eight parterres, each differently planted with flowers, punctuated by decorated pleasure-houses. Other flowers and even trees grew in large pots and tubs inside the palace, through which a stream was diverted to irrigate them. Encouraged by the Bishop, birds flew among them and in and out of the large glass windows (an innovation then). Gardens of herbs, vegetables, and fruit trees spread down the slopes to the river below. An army of gardeners and workmen planted and maintained it all.

The Bishop's garden was the first great botanical garden north of the Alps, only preceded by the garden of the Grand Duke of Tuscany at Florence. There he tried to bring together every known species of plant in the world, whether the wild flowers that grew in the fields outside or the exotic new plants then arriving from the ends of the earth. The sixteenth century had been a great age of discovery, not only of new parts of the world, in America and India and beyond, but also of the wonders of nature. Plants had been discovered and classified with a new scientific precision. The great botanists of this time, Gesner, Mattioli, Clutius, were all known to the Bishop, most of all Joachim Camerarius, who may have first inspired him in his botanical quest.

But Bishop von Gemmingen had a higher purpose even than scientific discovery. This was nothing less than to reconstruct the Garden of Eden, a veritable paradise on earth. It was this that led him to pay the merchants in Amsterdam and Antwerp huge sums for such novelties as the bulbs of newly discovered tulips, the Crown Imperial, the still more exotic cactus, peppers, and the potato, the amaranth, and the 'Marvel of Peru.' All this has been swept away by the hand of time. The castle that now stands on the crag is

new, and of all the Bishop's flowers only a few crept outside the garden walls to become naturalized in the Eichstätt countryside.

This higher purpose, however, had another and happier outcome. The Bishop's right-hand man, who helped him acquire the plants and build the garden, was an apothecary and physician of Nürnberg, Basilius Besler. Besler was entrusted with the task of giving the garden a different, and as it turned out, more permanent, form. This was a great picture book of all the plants in the garden, depicted life-size, to be called *Hortus Eystettensis, the Garden of Eichstätt*. The best artists were employed to draw them (the Bishop sent down baskets of fresh flowers to make sure the details were right), and their work was translated into exquisite black-and-white copper plates by the leading engravers of Augsburg and Nürnberg. The plates were of colossal size, just fitting on the largest sheets of paper then made, and each had an accompanying page of text, written by or for Besler. The whole book, 367 plates depicting over a thousand species, was the biggest single book that had ever been printed by 1613, when it came out.

Sadly, the Bishop had died the year before, although he had seen virtually the whole book before he died, including the pictorial title page, a gate through which can be seen God showing the Garden of Eden to Adam. To Besler, then, fell the task of financing publication, with a plain black-and-white edition for the book trade, which then as now revolved around the annual book fair at Frankfurt, and a special edition that could be colored by hand for potentates rich enough to pay for them. The trade edition sold out quickly, the colored was sold on an as-needed basis. Besler could look back on the whole enterprise as a success.

So it has remained ever since. The sinuous curves and twists of the drawings, Mannerist going on Baroque, faithfully reproduced by the engravers, are not as naturalistic to our eye as they must have been to those who first bought the book. The colors, however, remain as vivid now as then, and the sheer power with which each plant is rendered gives the great colored copies enormous impact today. It is difficult, too, in a mechanical and electronic age, to grasp the full magnitude of the task that the Bishop began and that Besler triumphantly concluded. It needed an impresario, one who combined botanical knowledge, artistic sense, and administrative ability. All these Besler possessed, and the ensuing pages witness the success with which this long-cherished plan was achieved.

Nicolas Barker

Note: The images in this book are reproduced from the copy of *Hortus Eystettensis* that was painted by George Mack in Nürnberg, in 1614–15. This is Mack's masterpiece and it must have been executed for a major client. Sometime before 1780 the copy entered the collection of King George III of England, and passed to the British Museum in 1824, and thence to the British Library.

Plate 1

With its dense spherical masses of simple flowers, this snow-
ball (I, center) should be classed with *Viburnum opulus* L.
(guelder rose), the sterile-flowered form of viburnum. The
snowball grows in damp woods and even in alluvial forests; it
is sometimes called marsh elder.

The garden broom, *Cytisus sessilifolius* L. (II, left), is a small
shrub about six feet high. Its beautiful yellow-gold blooms and
resistance to cold made it at one time a favorite ornament of
French-style parks. This species is sometimes found in abun-
dance, along with box and shadbush, in the stony rubble of
Europe's southern mountains.

Figure III, on the right, seems comparable to far less familiar
plants having silvery, silken leaves and downy pods with hairy
edges. These plants belong to a Balkan group, *Chamaecytisus
ciliatus* (WAHLENB.) ROTHM.

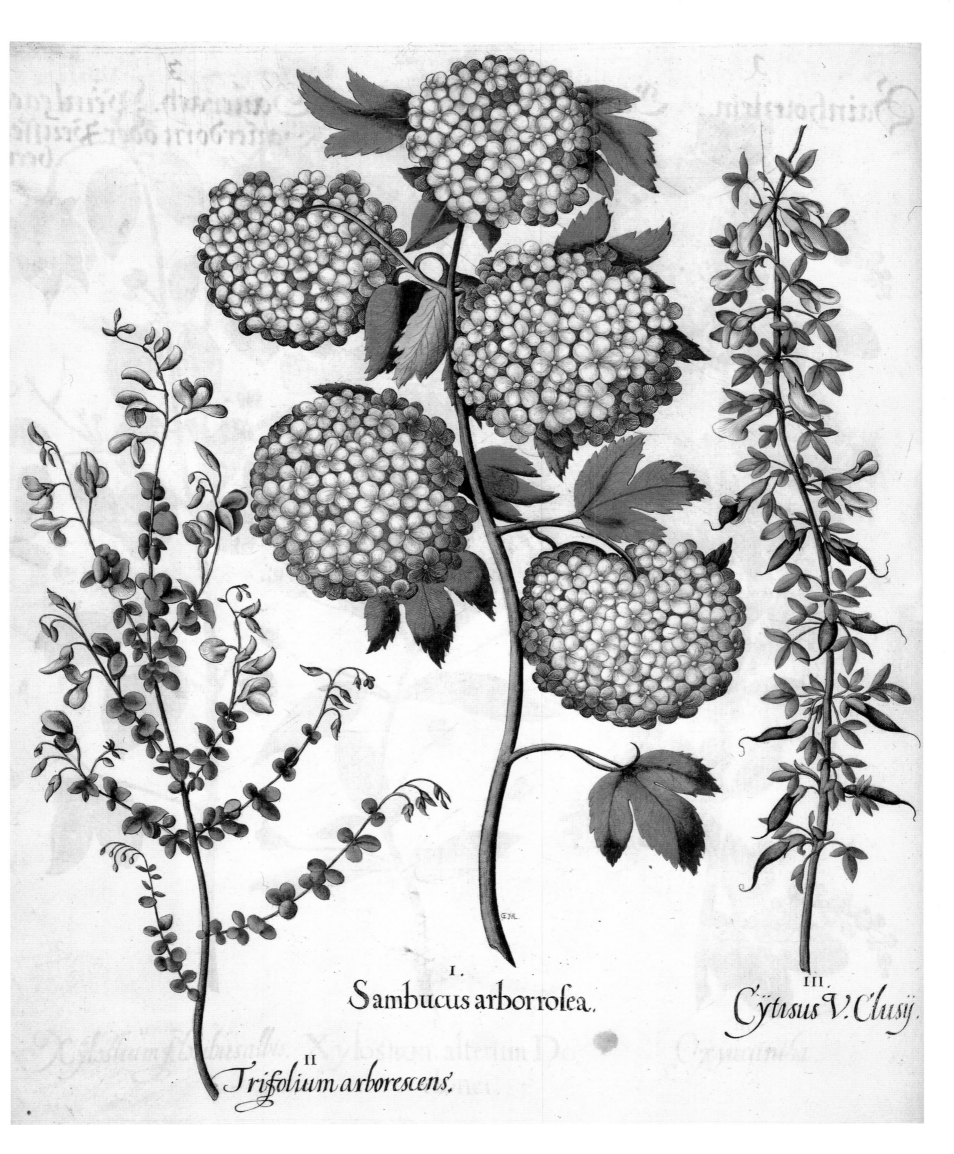

I.
Sambucus arborrosea.

III.
Cytisus V. Clusij.

II
Trifolium arborescens.

II. Garden broom

Leguminosae

I. Snowball viburnum

Caprifoliaceae

III. Low-growing alpine broom

Leguminosae

Plate 2

Ribes alpinum L. (I, below center), a mountain species of currants, has short clusters of small, red fruit and is found frequently in rocky woods from the French Massif Central to eastern Europe and even Siberia.

The common currant, *Ribes rubrum* L., is shown in three forms well known in gardens: the wild variety with relatively small fruit (II, below right) and two cultivated forms with larger fruits, one red (IIII, above right), the other white (V, above left).

The last drawing (III, below left) can reasonably be identified as black currant, *Ribes nigrum* L., a species fairly common in central Europe over an immense area extending to Manchuria and northward beyond the polar circle. It is widely cultivated today, often on terraced land near rivers.

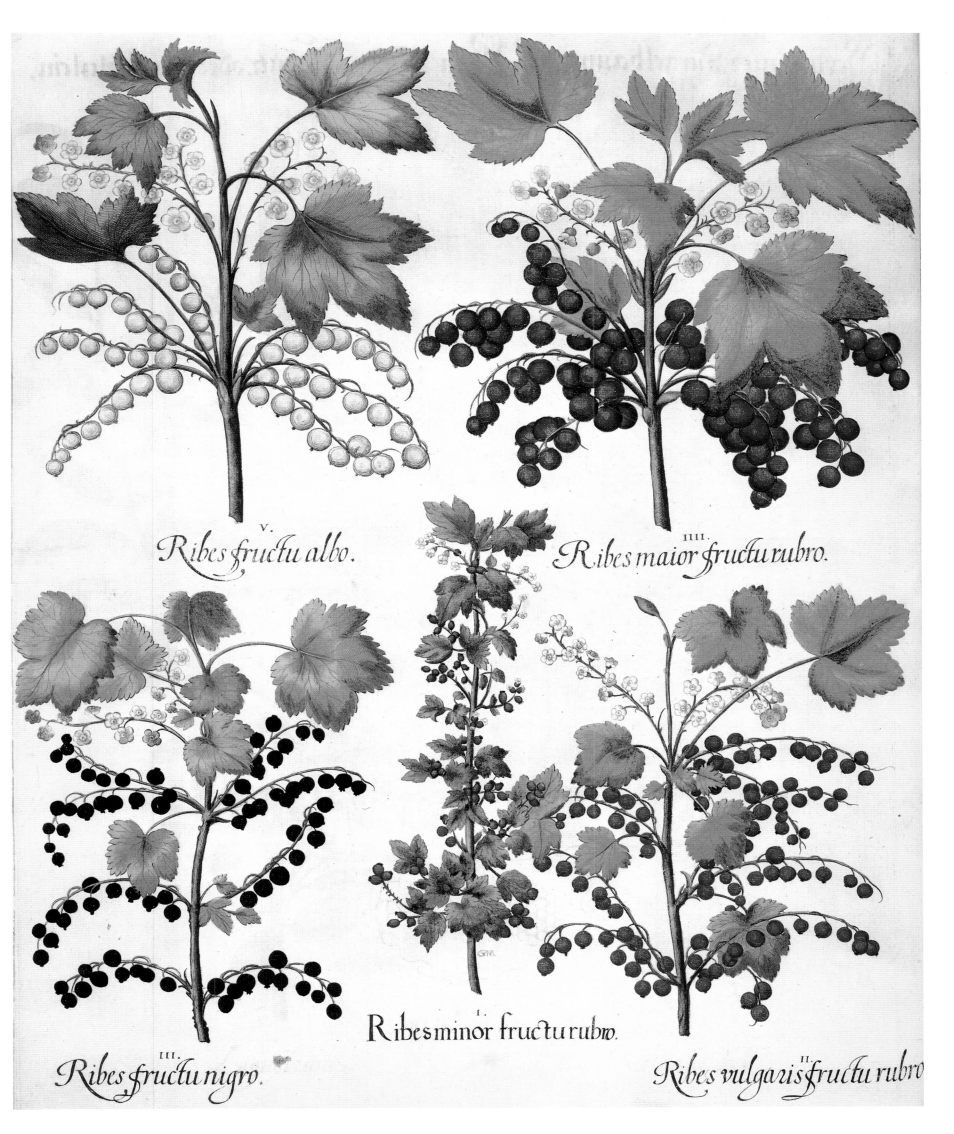

Ribes fructu albo.

Ribes maior fructu rubro.

Ribes minor fructu rubro.

Ribes fructu nigro.

Ribes vulgaris fructu rubro.

V. White currant
Saxifragaceae

I. Alpine currant
Saxifragaceae

IIII. Red currant
Saxifragaceae

III. Black currant
Saxifragaceae

II. Common currant
Saxifragaceae

Plate 3

In the history of botany, horticulture, and iconography, the
tulip occupies an extraordinary place and is the subject of
endless discussion by specialists. The word *tulipa*, unknown in
ancient Latin and only adopted as the botanical name of these
spring-flowering plants in the sixteenth century, is said to
come from a Turkish word for turban, a reference to the shape
of the flower.

The tulip became renowned about 1550, when plant lovers
throughout Europe developed a passion for a single, large-
flowered species, imported from Turkish gardens. This tulip,
called Gesner's—*Tulipa gesnerana* L.—is the ancestor of most old
horticultural forms. After 1561 tulips in ever-increasing
quantities were dispersed from central Europe westward. Tulip
mania raged throughout Europe until about 1635, when
exorbitant prices charged by owners brought it to an
abrupt end.

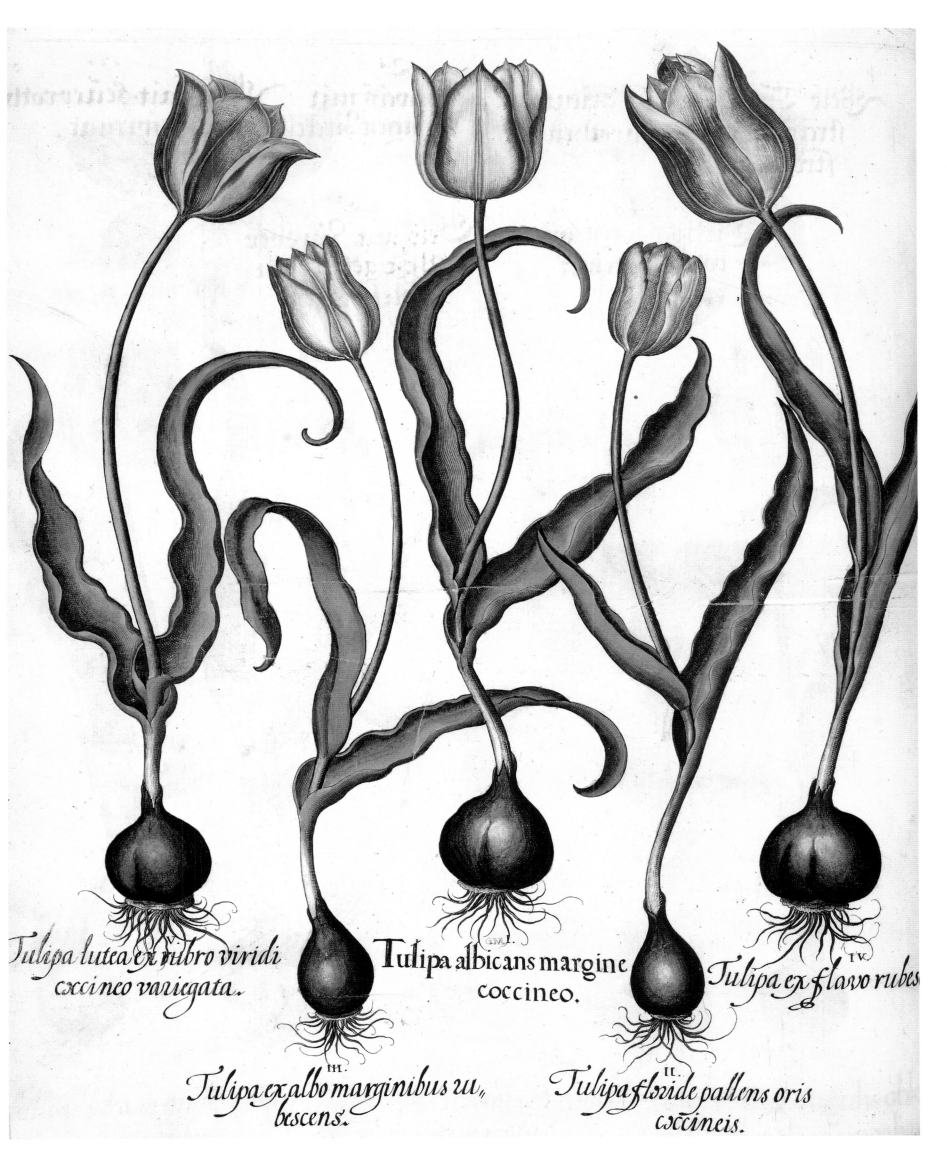

Tulipa lutea ex rubro viridi coccineo variegata.

Tulipa albicans margine coccineo.

Tulipa ex flavo rubes

Tulipa ex albo marginibus ru, bescens.

Tulipa floride pallens oris coccineis.

V. Late red tulip with green stripes
Liliaceae

I. Late white tulip edged rose-pink
Liliaceae

IV. Late red and gold tulip
Liliaceae

III. Early white tulip edged rose-pink
Liliaceae

II. Early bicolored tulip
Liliaceae

Plate 4

These three narcissi have a typical, short corona, and their yellow centers contrast with the petals, or segments, which are pure white.

The one in the center (I), with the large solitary flower, presents the characteristics of the poet's narcissus, *Narcissus poeticus* L., also called pheasant's-eye narcissus. The vivid yellow corona has a delicate orange border. In spring, this plant may form immense white covers in damp mountain meadows.

The two other narcissi here (II and III, left and right), with twin flower stalks, probably belong to a closely related species, *Narcissus x medioluteus* MILLER, a natural hybrid long cultivated. Descended from a cross between the poet's narcissus and a multiple-flowered Mediterranean species, it shows the classic variations of hybrids.

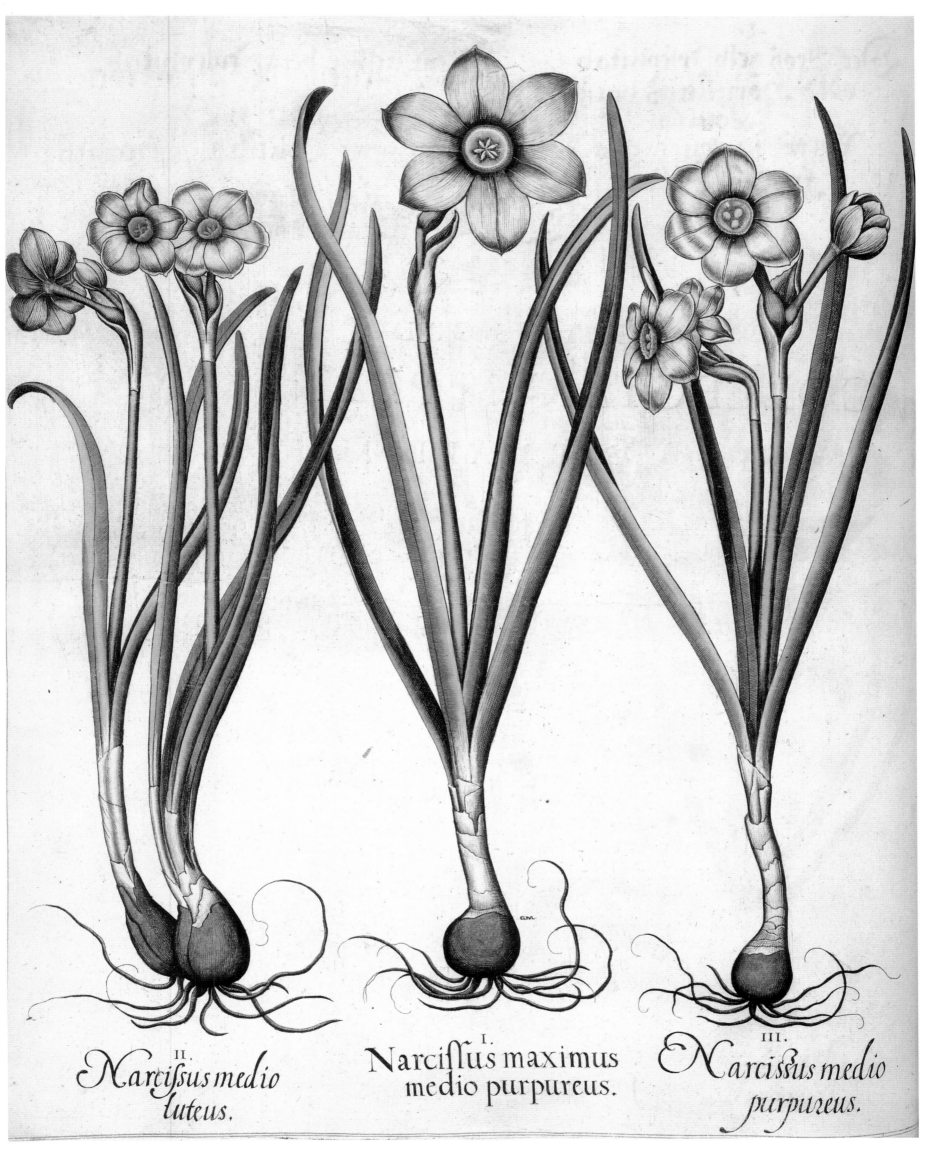

II.
Narcissus medio luteus.

I.
Narcissus maximus medio purpureus.

III.
Narcissus medio purpureus.

II. Twin-flowered narcissus with orange-
bordered yellow center

Amaryllidaceae

I. Poet's narcissus

Amaryllidaceae

III. Twin-flowered narcissus with
purple-bordered yellow center

Amaryllidaceae

Plate 5

In Besler's time, several hundred strains of tulips could be
counted; by about 1750, more than a thousand had been
described. Today—counting the influx of recently discovered
wild types and those of central Asia—as many as five thousand
listed varieties may exist.

Whatever our modern sources, it is virtually impossible to
relate present-day cultivated forms to varieties represented by
Besler in the *Hortus Eystettensis*, with the exception of the
collective species *Tulipa gesnerana* L. So although the labels are
not of much help, the drawings do represent strains of Gesner's
tulip. Their appeal lies in Besler's vivid renderings and also
proves that a multiplicity of forms existed in his day.

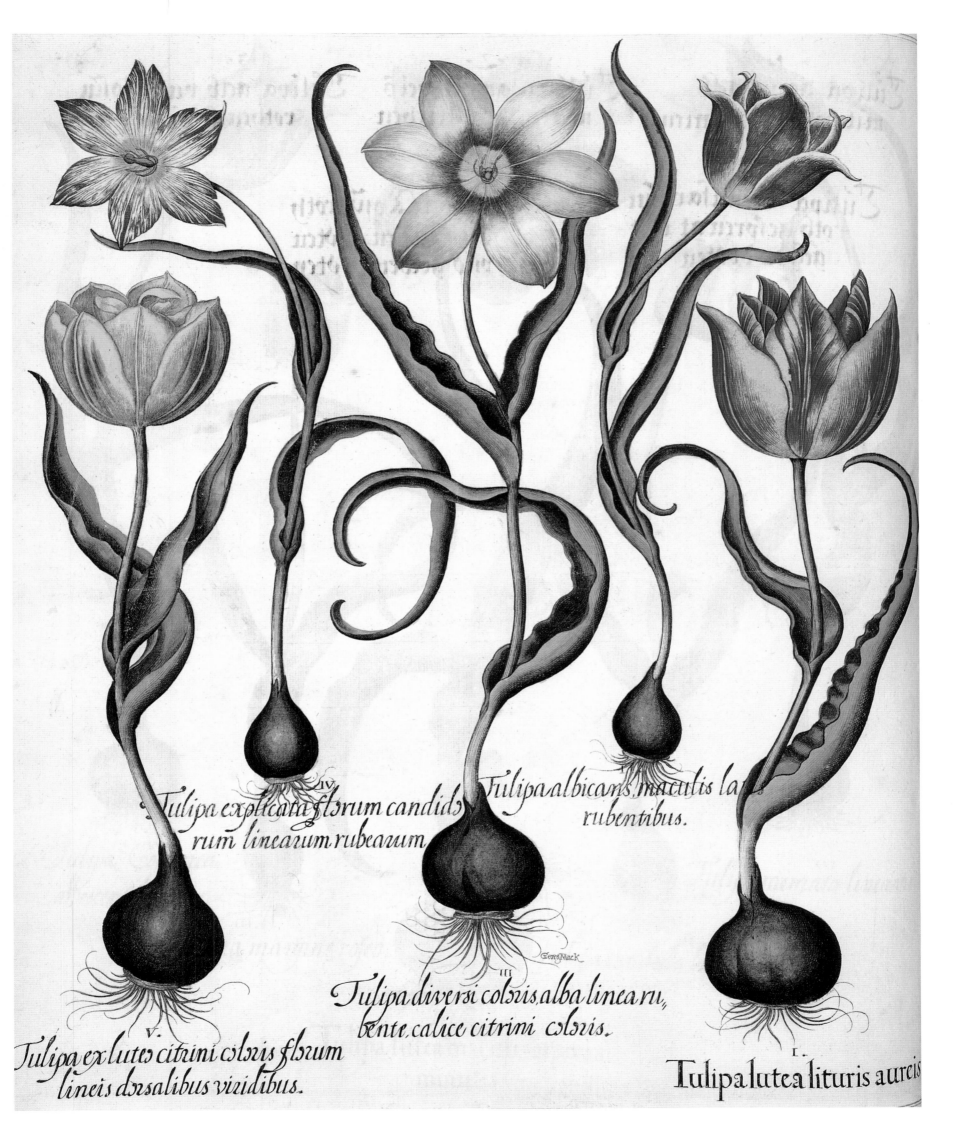

Tulipa explicata florum candidorum linearum rubearum.

Tulipa albicans maculis lati rubentibus.

Tulipa diversi coloris, alba linea ru, bente, calice citrini coloris.

Tulipa ex luteo citrini coloris florum lineis dorsalibus viridibus.

Tulipa lutea lituris aureis

IV. Tulip with tepals streaked white and crimson
Liliaceae

III. Silver-white tulip with blue and yellow halo
Liliaceae

II. Early crimson tulip edged white
Liliaceae

V. *Sylvestris*-type tulip tinged green
Liliaceae

I. Broken yellow *sylvestris*-type tulip
Liliaceae

Plate 6

This veritable fireball (I, center) is an anomaly, a blood-red
teratological variant of *Lilium bulbifernum* L. var. *croceum*, in which
the somewhat fasciated stem is flattened, the inflorescence
shortened, and the number of flowers multiplied. Besler
considered his specimen, found in 1611, to be a spectacular
rarity, with its eighty-four flowers.

The lesser centaury, *Centaurium erythraea* RAFIN., a humble
little flower, here accompanies the lily (II and III, right and
left). In its pink or white wild forms this annual (or more
often biennial) plant has a loose, rather fragile habit and bears
small star-shaped flowers which open only after the dew has
disappeared and the sun has dried the ground.

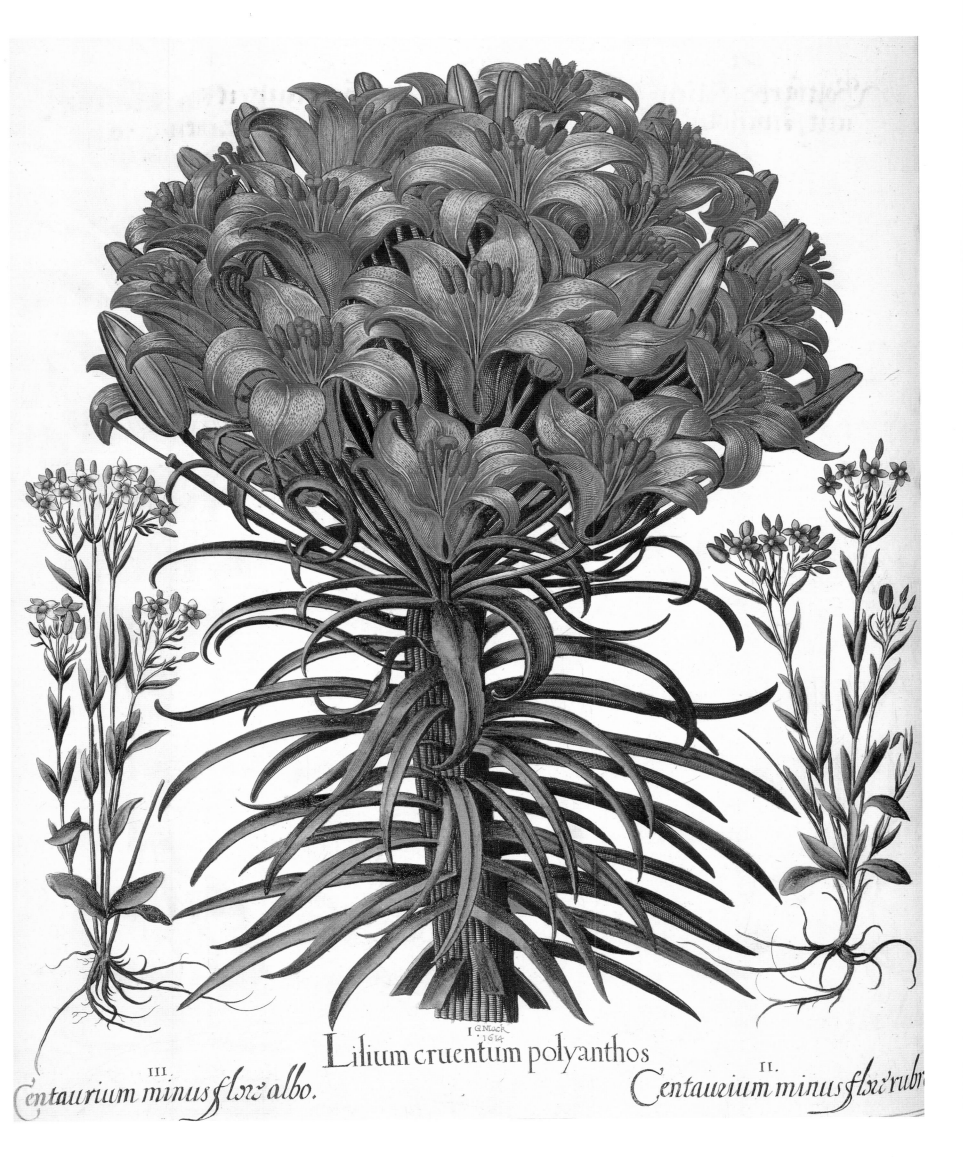

III.
Centaurium minus flore albo.

Lilium cruentum polyanthos

II.
Centaurium minus flore rubro

III. White lesser centaury

Gentianaceae

I. Orange lily, mutation

Liliaceae

II. Pink lesser centaury

Gentianaceae

Plate 7

Among the many cultivars of *Hibiscus syriacus* L. hardy in the European climate, the bicolored kinds are popular. Its blossoms have five or six petals, indicating a step in the direction of double flowers, a tendency in hibiscus on which hybridists capitalize. Modern cultivators may be single or double and come in colors ranging from violet-black to blue-violet, to mauve, to pink, to cream and pure white. Pastel varieties are often marked with dark brown or carmine.

Roses of Sharon do best in hot climates. An extraordinary red or yellow variety comes from the tropics. Cultivated varieties are derived from the 250 wild species from tropical Hawaii, Madagascar, Florida, Ethiopia, Japan, and southern Africa.

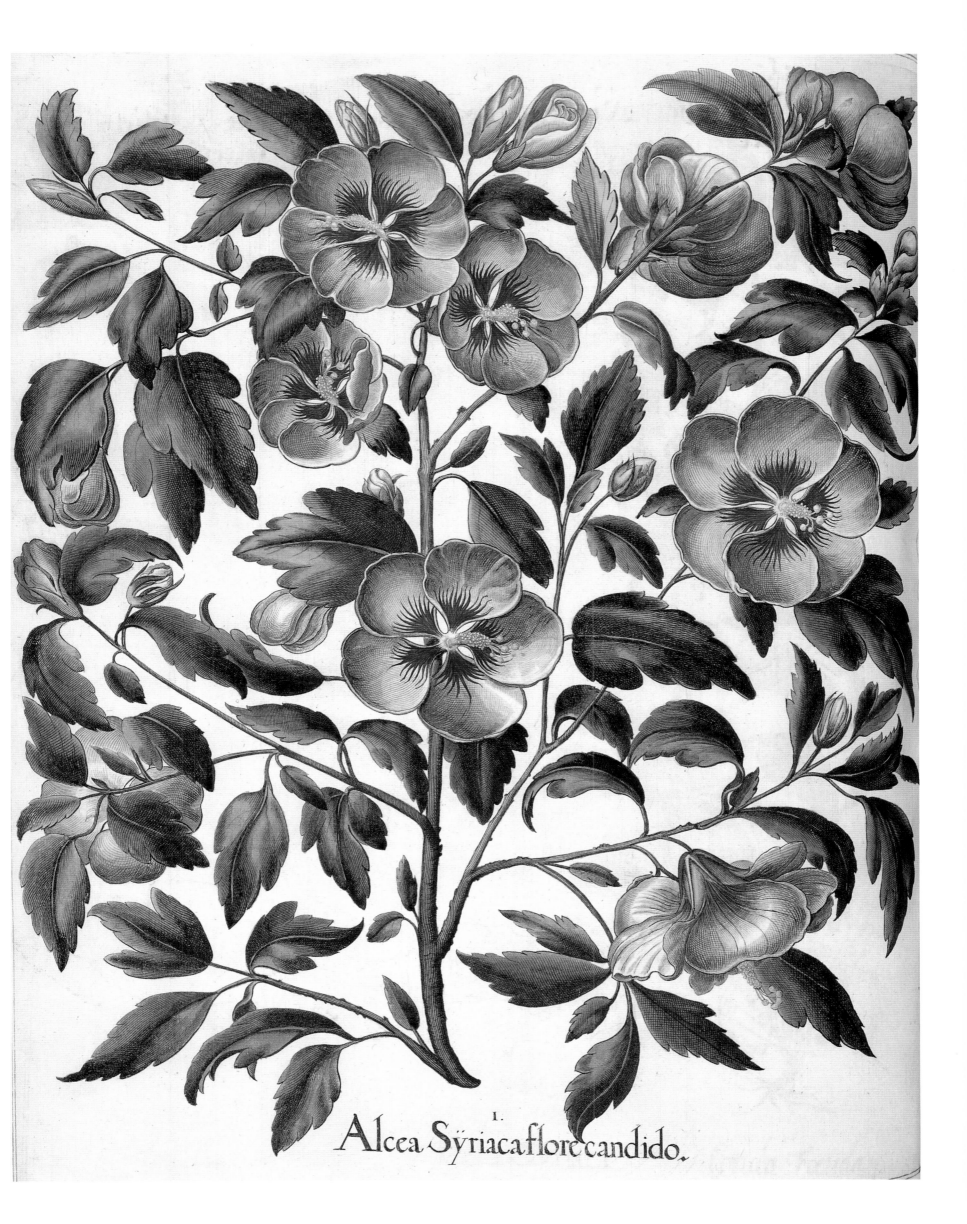

I.

Alcea Syriaca flore candido.

I. White rose of Sharon

Malvaceae

Plate 8

Of all garden plants, roses have the most complicated history.
Though the great majority of garden roses are double-flowered,
most have several single-flowered wild species in their ancestry.

Besler believed that the two roses labeled I and II (below
right and below left) were variants of *Rosa x alba*, which was
common in gardens at the time. He remarked on the fragrance
of the white specimen labeled IV (above left) and called it
"provincialis." Fragrance is a characteristic of the French rose
Rosa gallica L., but the strains of *gallica* are rare, and *gallicas* do
not have the thornless stems we see here.

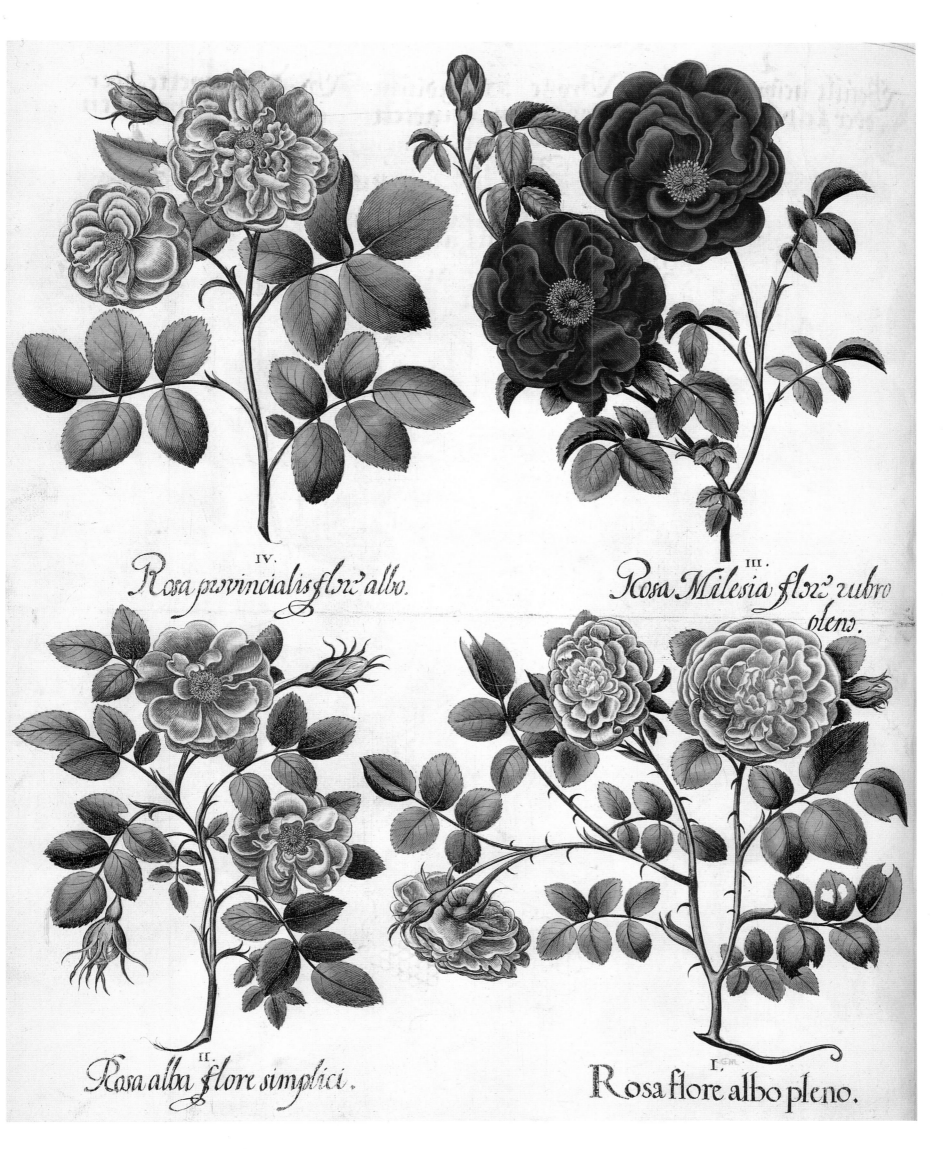

IV. *Rosa provincialis flr̃ albo.*

III. *Rosa Milesia flr̃ rubro pleno.*

II. *Rosa alba flore simplici.*

I. *Rosa flore albo pleno.*

IV. White semidouble-flowered rose

Rosaceae

III. Red *gallica* rose

Rosaceae

II. White rose

Rosaceae

I. White double-flowered rose

Rosaceae

Plate 9

The ancient appellations *mas* (male) and *foeminea* (female)
as given to well-known peonies correspond to no biological
reality. *Mascula* continues to be applied for rough purposes of
classification to the corallina peony, *Paeonia mascula* (L.) MILLER
(I, center). The distinction between plants in terms of "male"
and "female" has existed a long time, and possibly served to
designate degrees of hardiness or different colorations.

Polygalas, or milkworts, are small, rather fragile plants
whose numerous stems end in narrow clusters of highly colored
flowers most often blue, violet, or mauve, but also sometimes
pink. Polygalas inhabit both dry and damp meadows at high
and low altitudes throughout a great part of the world. Among
several species, the American seneca, *Polygala senega* L., possesses
proven medicinal properties.

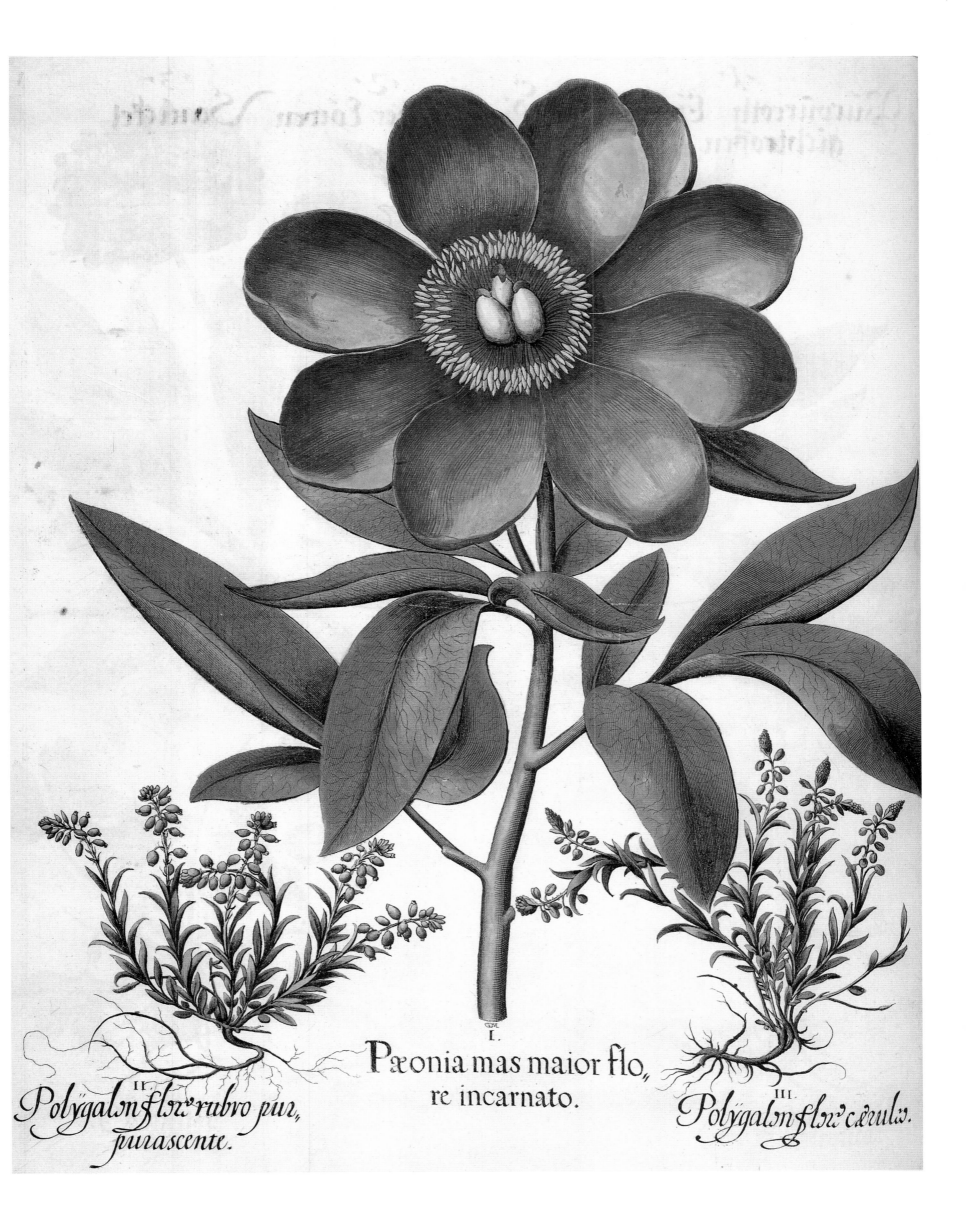

Polygala flore rubro pur,
purascente.

Pæonia mas maior flo,
re incarnato.

Polygala flore cærule.

II. Common milkwort

I. Large crimson corallina peony

III. Tufted milkwort

Polygalaceae

Paeoniaceae

Polygalaceae

Plate 10

It would be unreasonable to try to match the irises of the *Hortus Eystettensis* to modern types, or to compare them with our two hundred recorded wild species, some of which come from extremely restricted regions probably not even botanically explored in Besler's day.

Nonetheless, some of the thirty European wild species must have been grown in gardens for a long time, and by the late sixteenth century certain other species would have arrived from central Asia, the Far East, and America. Botanically, the genus *Iris* has twelve divisions, but for horticultural purposes it can be divided into two: bulbous iris and rhizomatous iris, and the latter category is further divided into bearded (aristate) and beardless.

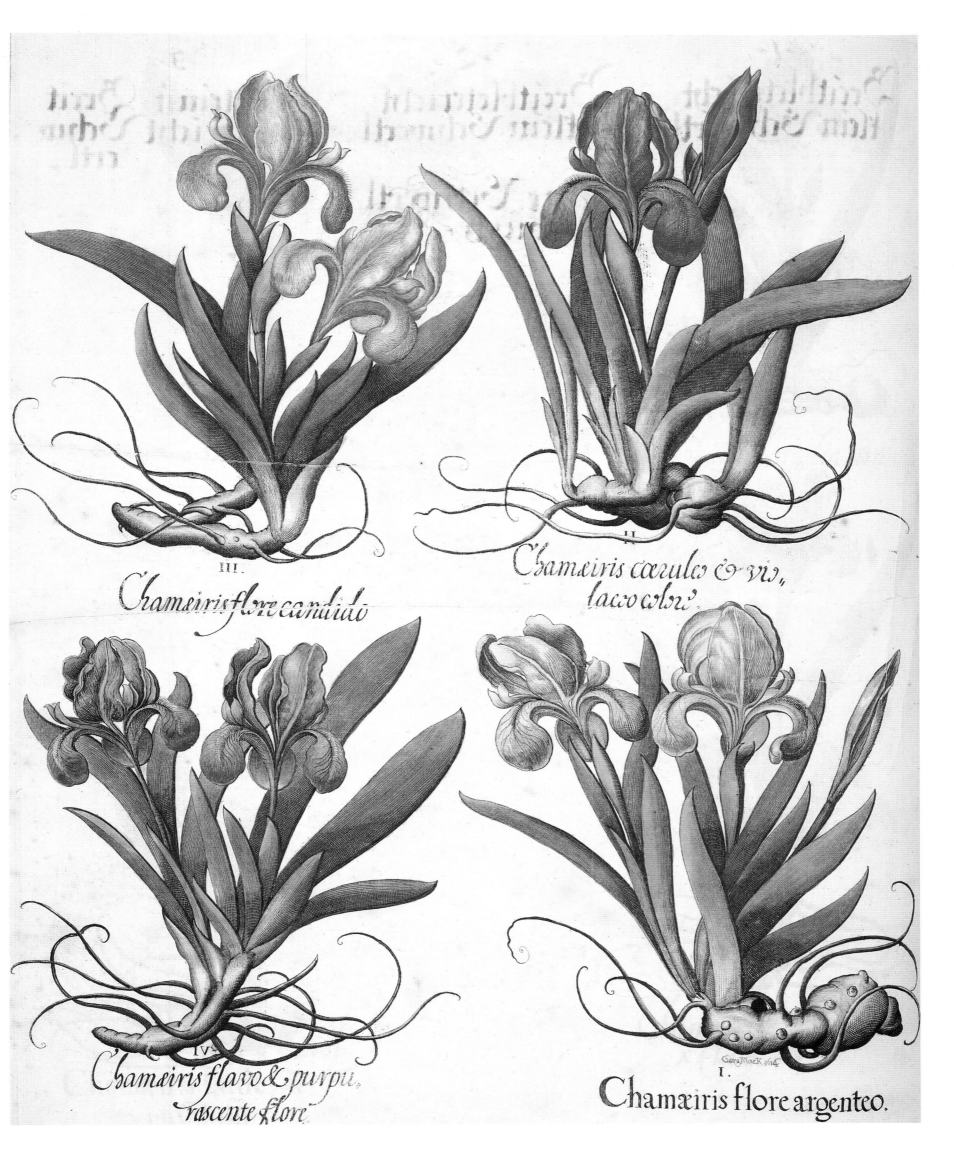

III. *Chamæiris flore candido*

II. *Chamæiris cœruleo & vio-
lacео colore*

IV. *Chamæiris flavo & purpu-
rascente flore*

I. *Chamæiris flore argenteo.*

III. White dwarf bearded iris
Iridaceae

II. Purple dwarf bearded iris
Iridaceae

IV. Variegated dwarf bearded iris
Iridaceae

I. Silver-white dwarf bearded iris
Iridaceae

Plate 11

This is an ancient iris species, from which the greatest number
of modern horticultural strains of bulbous iris are descended.
The specimen in the center (I), which Besler calls "Anglicana"
(English), has pretty much the colors of its wild ancestor *Iris
xiphioides* J.F.EHRH. The blue color of the two irises at left and
right (II and III) is similar to, though a little paler than, the
blue *Iris xiphium* as it is typically found in nature.

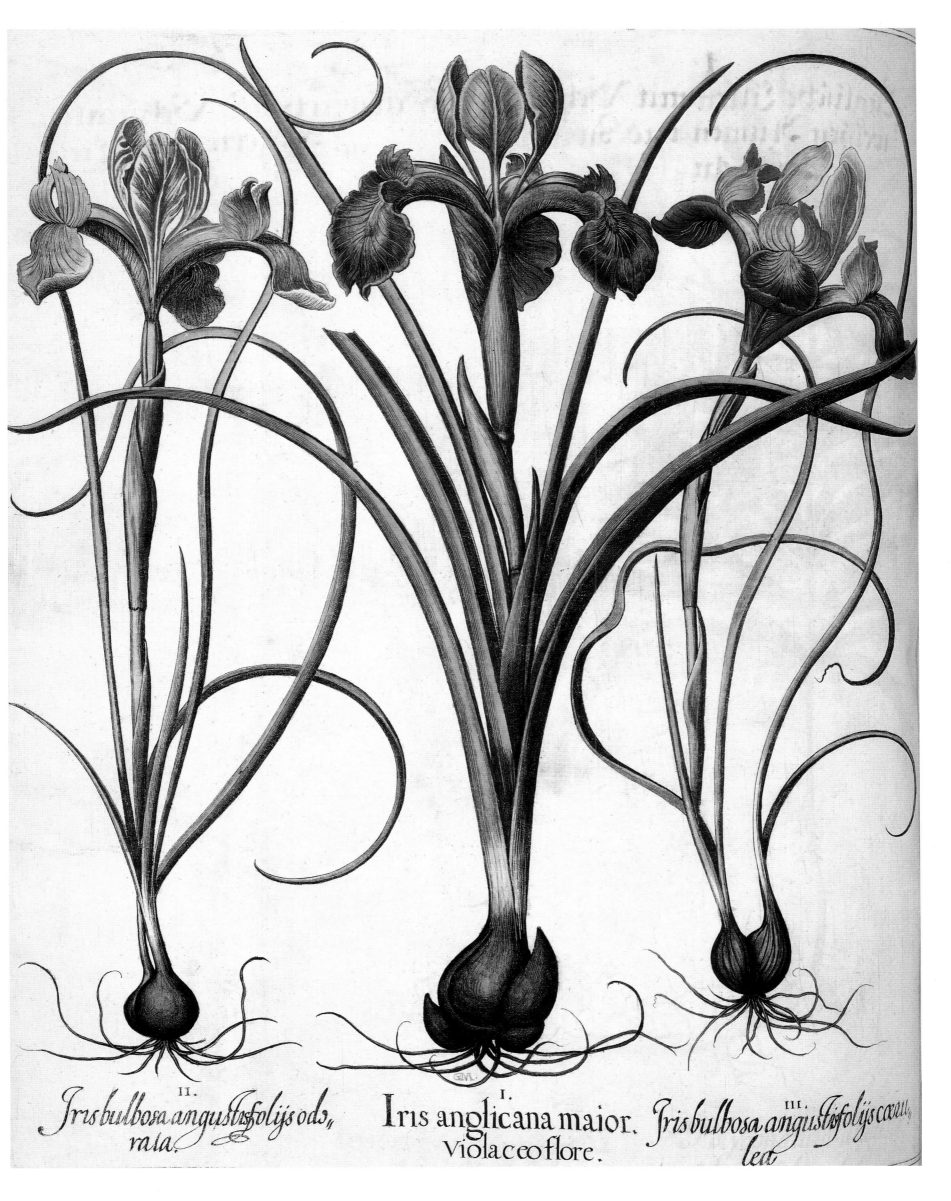

II.
Iris bulbosa angustifolijs odo-
rata.

I.
Iris anglicana maior.
violaceo flore.

III.
Iris bulbosa angustifolijs cœru-
lea.

II. Blue Spanish iris
Iridaceae

I. Purple English iris
Iridaceae

III. Blue Spanish iris
Iridaceae

Plate 12

Citrus fruits probably originated in tropical east Asia but have been cultivated in the Mediterranean basin for centuries. Their history in cultivation is complex. However distinct our present-day kinds may appear to be from each other, identification of the different species, varieties, and cultivars is extremely difficult. The orange, introduced into Europe in the form of the Seville orange (bitter orange) by the Arabs, was surely grown in Seville as early as the twelfth century. The citron was grown in Palestine in ancient times and seems to have been the only citrus fruit the Romans knew. It is said to have been cultivated in Naples about the year 1000 and to have spread from there. Besler depicts a citron, *Citrus medica* L., in figure II (left). Figures I and III (center and right) show two oranges, both belonging to the species *Citrus aurantium* L. The one with the larger fruits seems to be our modern orange. The specimen bearing the smaller fruit must be the Seville orange, brought to Greece from Asia by Alexander the Great.

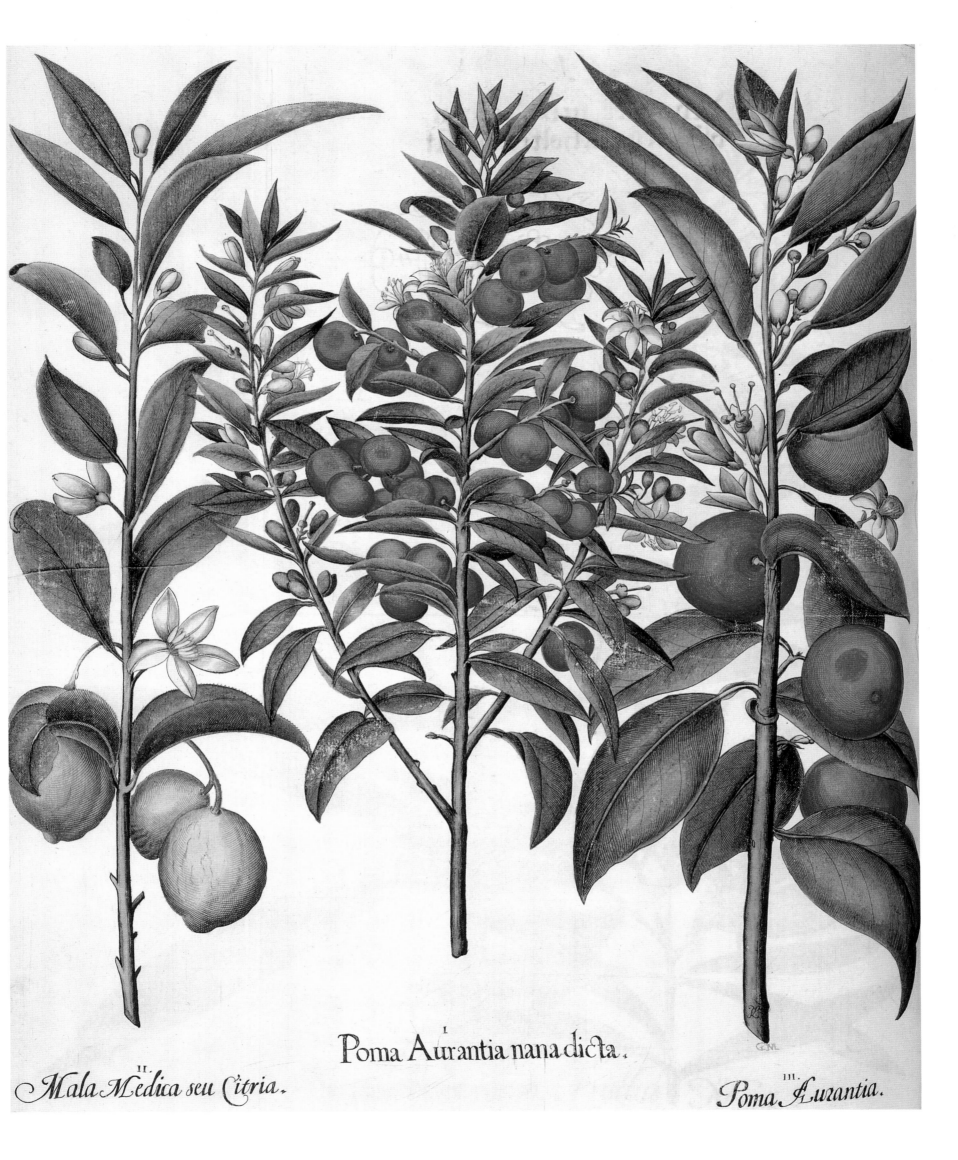

Poma Aurantia nana dicta.

Mala Medica seu Citria.

Poma Aurantia.

II. Citron

Rutaceae

I. Seville orange

Rutaceae

III. Orange

Rutaceae

Plate 13

Pomegranates (*Punica granatum* L.) are used to make desserts
and refreshing syrups. When split open, the fruits reveal a
profusion of seeds and in the Mediterranean have been
a symbol of fertility going back to ancient times.

Figure II (left) has been misinterpreted as *Terminalia bellirica*
(GAERTN.) ROXB., a Malaysian tree possibly known to the
Arabs but not to sixteenth-century Europe. The fruit-bearing
branch in figure II must belong instead to the rather unusual
cherry plum, *Prunus myrobalana* (L.) LOISEL., listed today as
Prunus cerasifera J.F.EHRH. It comes from the eastern
Mediterranean and is closely related to the purple-leaved
Prunus pissardii CARRIÈRE. The cherry plum bears large, bright
red fruit with very juicy and acidic green flesh.

In spite of the length of the rounded leaves, the heavily
laden branch seen in figure III (right) must be an apricot,
Prunus armeniaca L. Besler helps us arrive at this conclusion
by comparing the fruit to the peach and describing it as
having a flat stone.

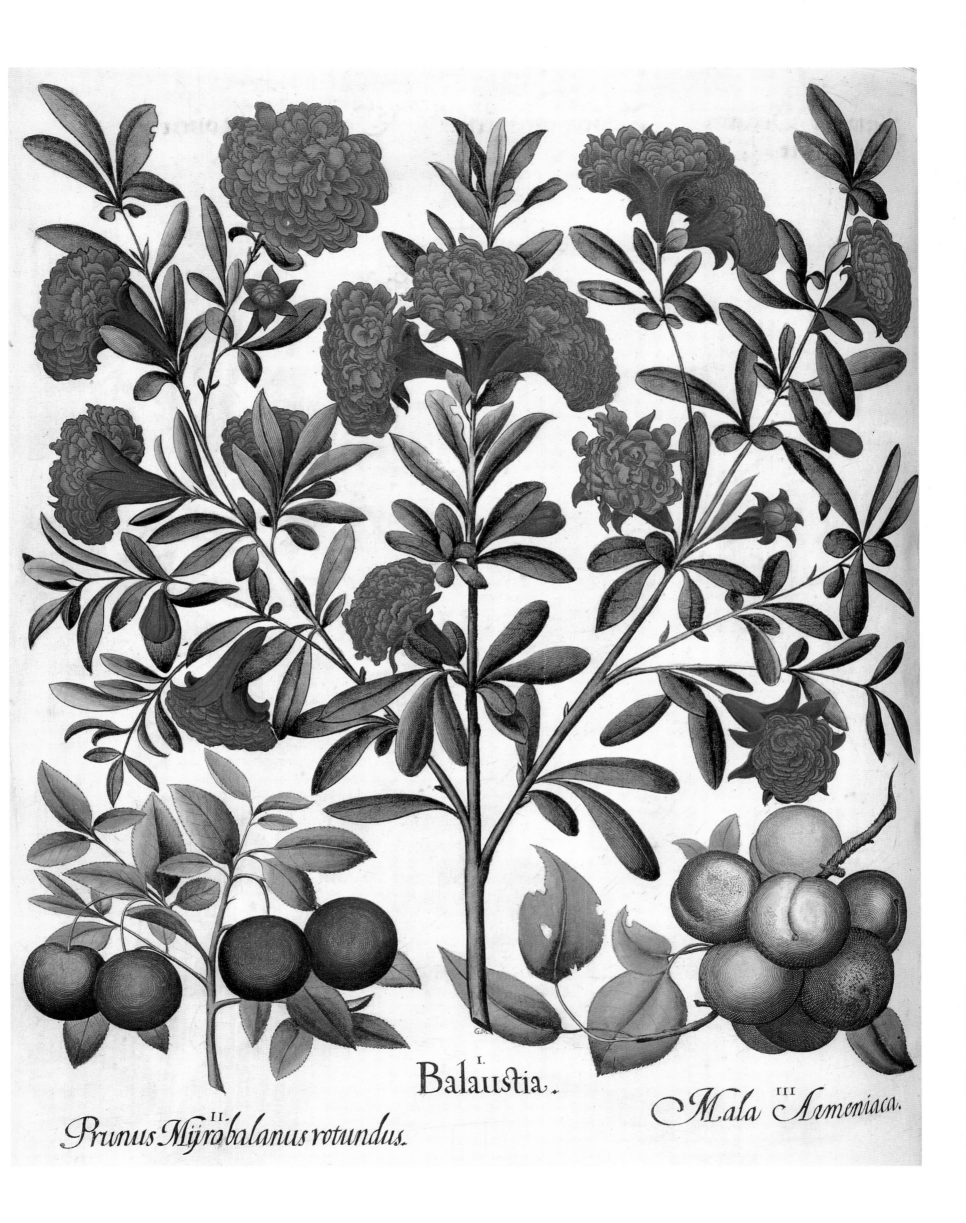

I.

Balaustia.

II.

Prunus Mijrobalanus rotundus.

III.

Mala Armeniaca.

II. Cherry plum

Rosaceae

I. Double-flowered pomegranate

Punicaceae

III. Apricot

Rosaceae

Plate 14

White forms of *Digitalis purpurea* L. (I, right), usually the result
of horticultural selection, are rarely seen in nature. In the wild
the species has a slender habit and dark purple flowers, which
are a paler color and strongly spotted on the inside (II, left). It
is a native of western Europe and the sub-Atlantic zone but is
absent along the shores of the Mediterranean. *Digitalis purpurea*
thrives in France and Germany, except in those regions with
the highest mountains. Although all its parts are poisonous, the
plant has important medicinal uses.

The orange hawkweed, *Hieracium aurantiacum* L. (III, center),
is one of the most representative of 350 species and several
thousand forms of this genus in Europe. It often grows among
rocks and in high mountain pastures and is widely naturalized
in much of coastal North America.

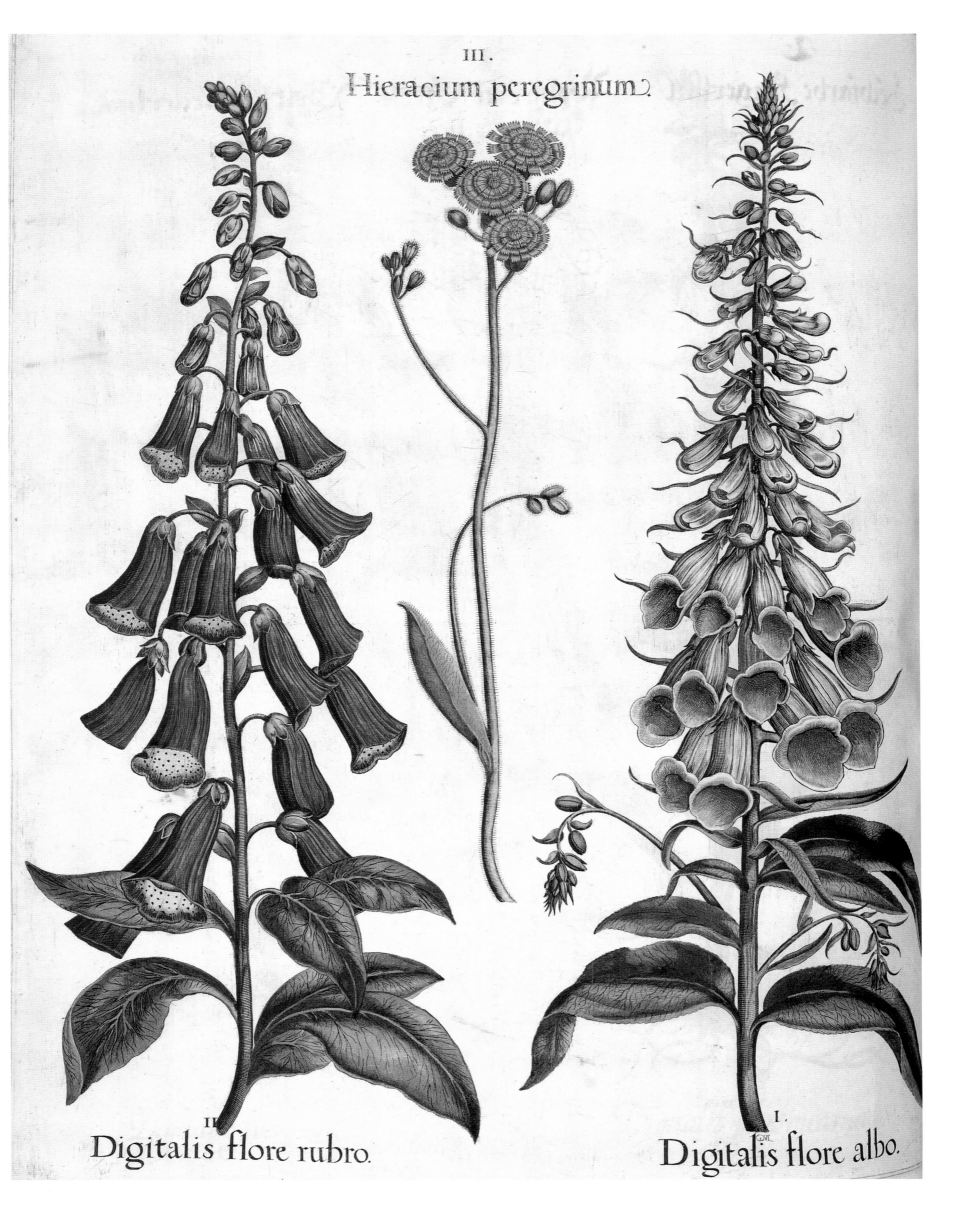

III.

Hieracium peregrinum.

II.
Digitalis flore rubro.

I.
Digitalis flore albo.

II. Common pink foxglove

Scrophulariaceae

III. Orange hawkweed

Compositae

I. White foxglove

Scrophulariaceae

Plate 15

The cinnabar-red color, the slightly spotted flowers, the leaves much different from those of the lesser turk's-cap, and the flower stems of varied length attached almost at the same level are typical characteristics of the scarlet turk's-cap lily, *Lilium chalcedonicum* L. The specimen shown here (I and II, center and left) is probably a later-flowering individual of this species.

The "Hyacinth" Besler illustrates at right (III) is a squill, a member of the only European species to flower late, at the end of summer, from August to November.

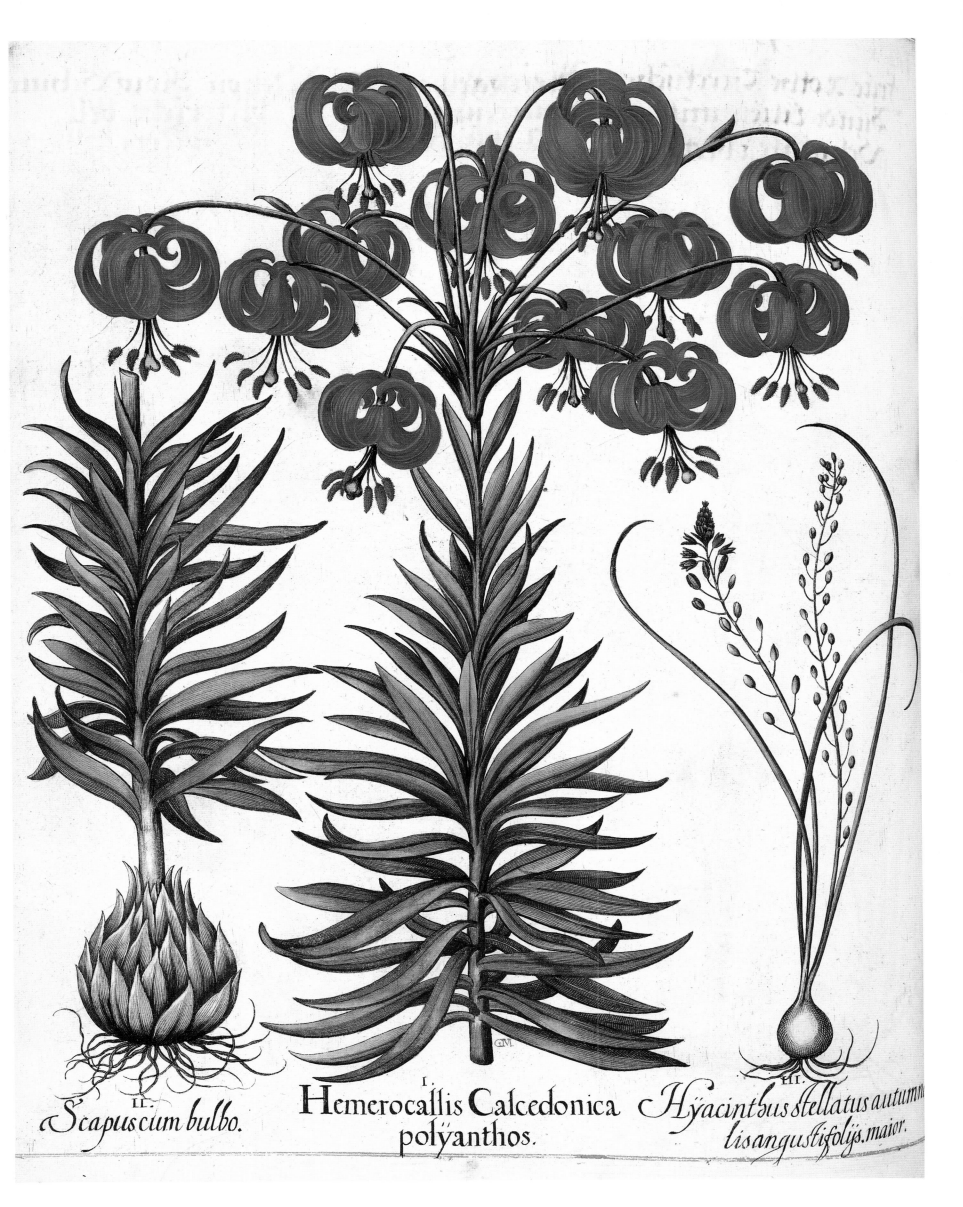

II.
Scapus cum bulbo.

I.
Hemerocallis Calcedonica
polyanthos.

III.
Hyacinthus stellatus autumnlisangustifolijs.maior.

I., II. Scarlet turk's-cap lily (Chalcedon lily) and bulb

III. Autumn squill

Liliaceae

Liliaceae

Plate 16

The sunflower belongs to one of the largest families in the plant world, the *Compositae*, which in Europe includes more than 160 genera. The genus occupies a unique place among European ornamental flora.

The common sunflower, *Helianthus annus* L., appears to have been in cultivation at the end of the sixteenth century, when its enormous size brought it rapid popularity. The plant is generally considered to have originated in southern Latin America—"Peruvianus," Besler says. Other sunflowers grown today, such as the Jerusalem artichoke, *Helianthus tuberosus* L., and *Helianthus strumosus* L. appear to have arrived in Europe after 1700.

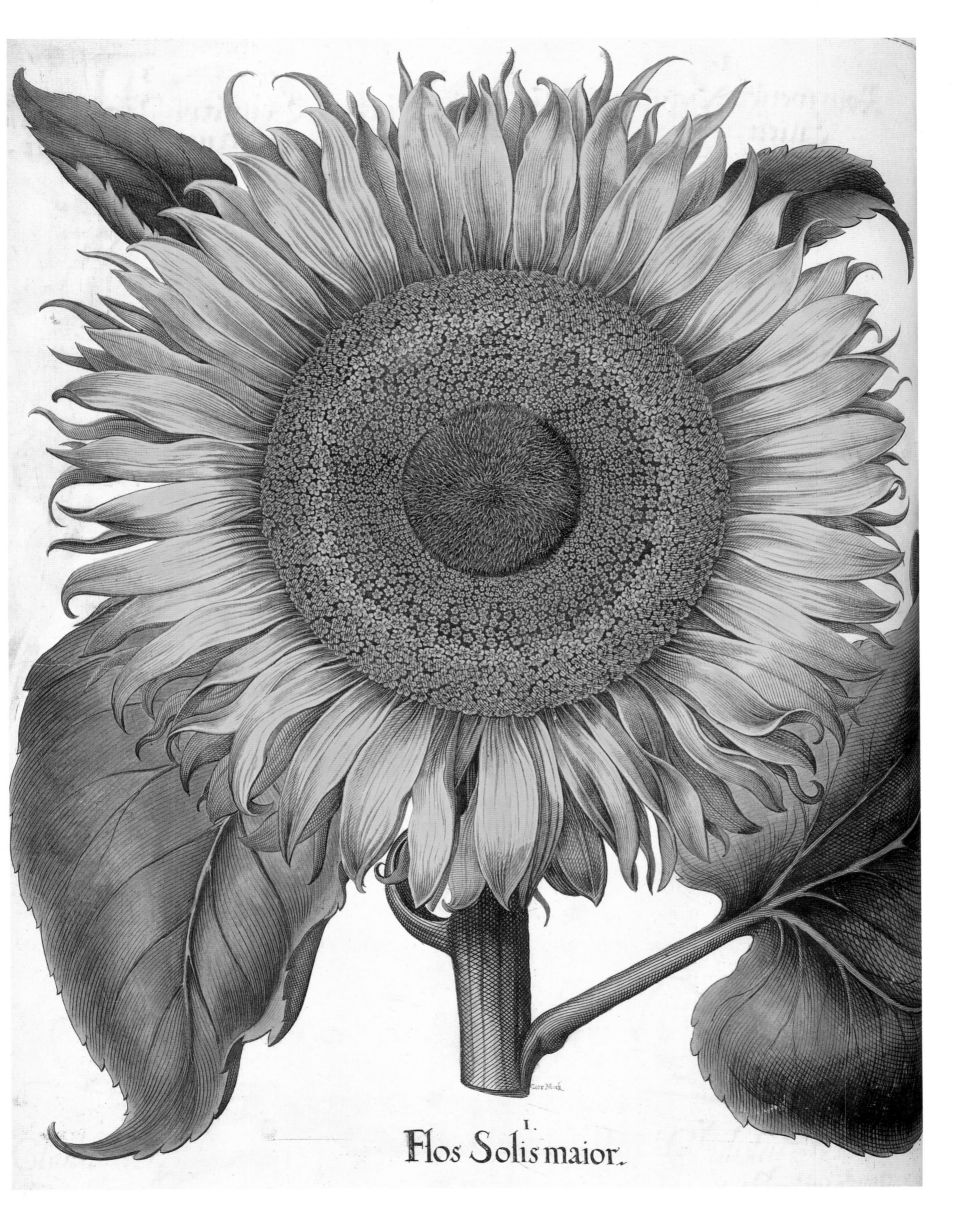

Flos Solis maior.

I. Common sunflower

Compositae

Plate 17

Numerous varieties of the daisy are common throughout
Europe, Asia, and North America in such widely differing
habitats as fields and woods, mountain screes, and brackish soil.

Figure II (left) is not the corn marigold, *Chrysanthemum segetum* L.,
but the crown daisy of garland chrysanthemum, *Chrysanthemum
coronarium* L., a wild plant long cultivated in Europe and often
naturalized. The daisy widely sold in flower shops is the white
marguerite, or Paris daisy, *Chrysanthemum frutescens* L., a plant
originally from the Canary Islands.

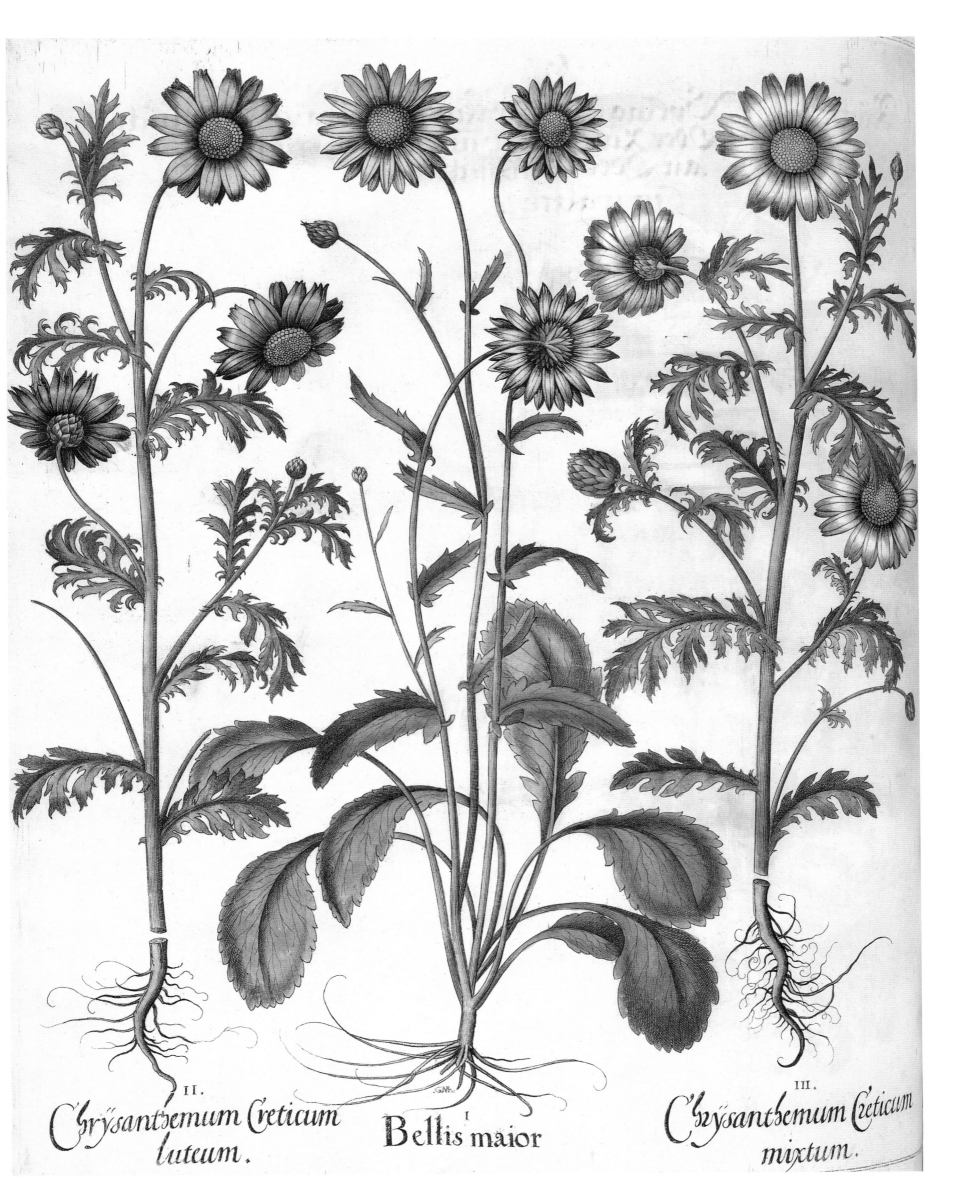

Chrysanthemum Creticum luteum.

Bellis maior

Chrysanthemum Creticum mixtum.

II. Yellow crown daisy

Compositae

I. Daisy

Compositae

III. Wild crown daisy

Compositae

Plate 18

Basils, including the familiar sweet basil, comprise several
species and probably even two botanical genera: *Ocimum*, of
which the sweet basil, or true basil, is a member, and *Perilla*.
Ocimums have six to ten flowers clustered on each floral
verticil. The different species seem to have originated in hot
regions of southern Asia and Africa.

It can be assumed that the two basils shown here are specimens
of true basil, *Ocimum basilicum* L. The deeply indented leaves and
absence of the typical ocimum calyx makes us suspect that
Besler's "Ocimum Crispum" of figure II (left) is a curly leaved
variety of *Perilla frutescens* (L.) BRITT.—among the many cultivars
of which is a 'Crispa', in popular use today.

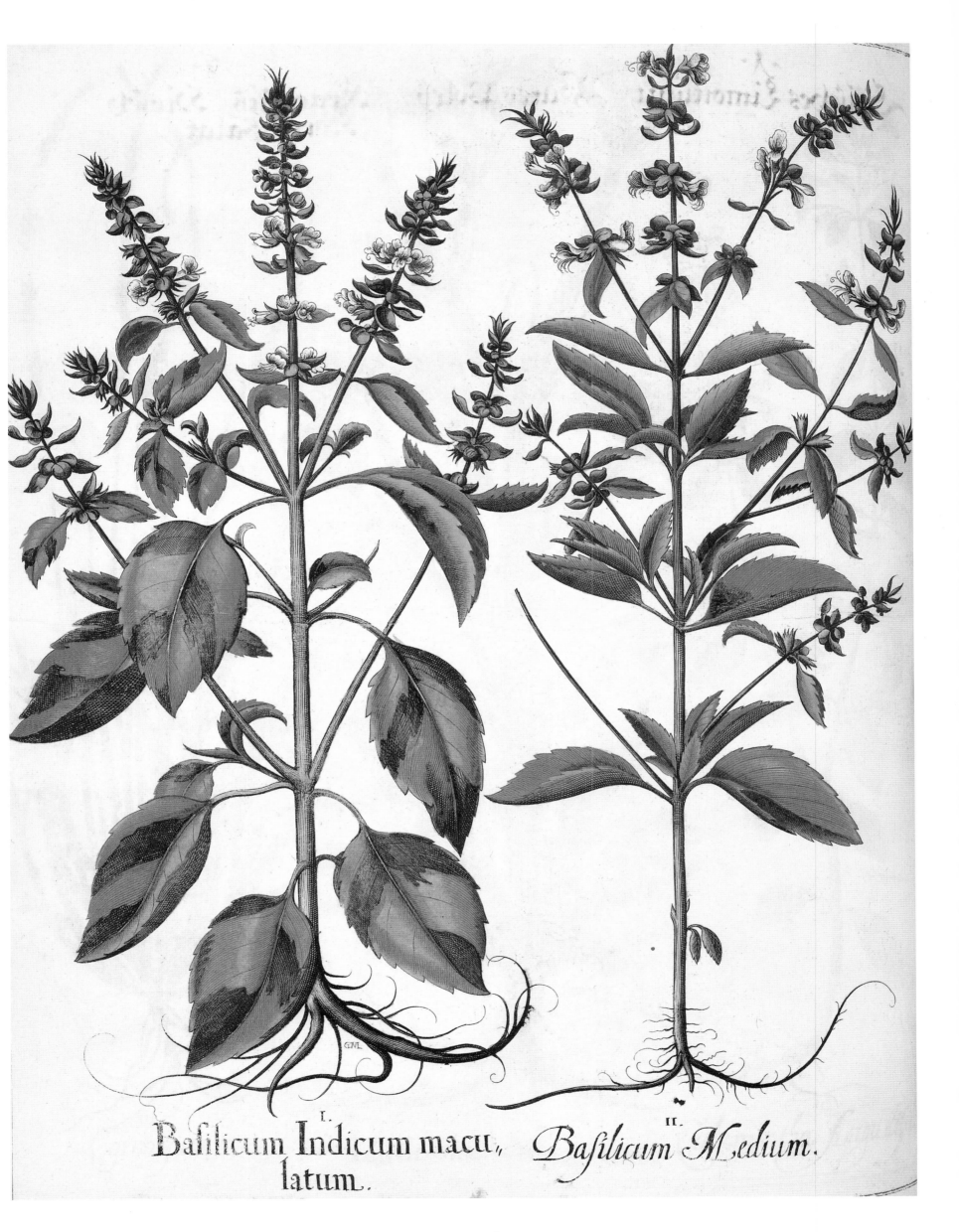

I.
Basilicum Indicum macu,
latum.

II.
Basilicum Medium.

I., II. Basils

Labiatae

Plate 19

Red peppers, or pod peppers, form a group whose identification and classifications are extremely difficult—even impossible when old engravings, however beautiful and precise, are our only evidence.

Red peppers belong to the same plant family as the tomato, the potato, deadly nightshade, henbane, and belladonna. These New World peppers derive their popular name from the similarity of taste between some kinds—cayenne, for example—and certain kinds of true pepper, belonging to the distant family Piperaceae. Originally from Central and South America, they are found growing on all continents, even in temperate regions.

The cultivation and use of peppers for food are probably ancient and involved different strains of *Capsicum*. The Aztecs and other Amerindian peoples from Mexico to Peru used peppers as food, condiments, medicine, and even as a topical aphrodisiac. A form close to the chili pepper or cayenne (belonging to the *longum* group) became known to Europeans at the time of Columbus. Peppers brought to Europe by Columbus were acclimatized in Spain by about 1515, and by 1550 plants with red and yellow berries in varying forms were known. In the middle of the sixteenth century, peppers were cultivated in England.

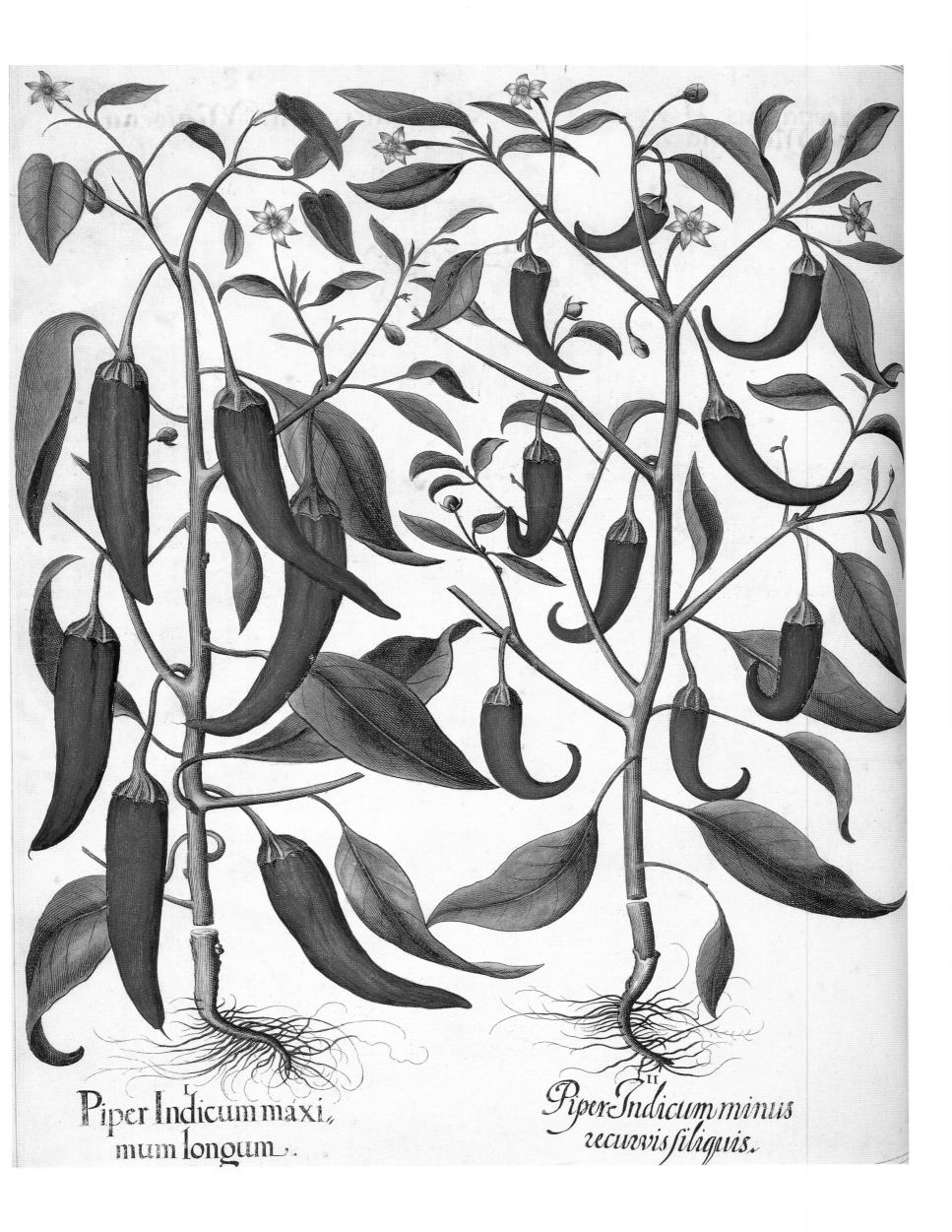

Piper Indicum maximum longum.

Piper Indicum minus recurvis siliquis.

I. Red peppers with long, pendant fruit

Solanaceae

II. Red peppers with long, pendant fruit

Solanaceae

Plate 20

Besler's illustrations of the flower spikes of these hollyhocks, or garden mallows, show double flowers (IIII and V, left and right), and three single blossoms (I–III, center) possessing the more typical characteristics of the mallow family and showing a further range of colors. Forms with single flowers seem to have been rare; double-flowered and even *flore-pleno* varieties have always been more popular.

Besler's double-flowered hollyhocks are rose-colored, white, maroon, and crimson; his single-flowered blooms are tinted pink, white, and crimson. Our many modern cultivars have a greater range of colors, from white and cream to pale yellow and lemon, to shades of pink, red, maroon, and even maroon-black.

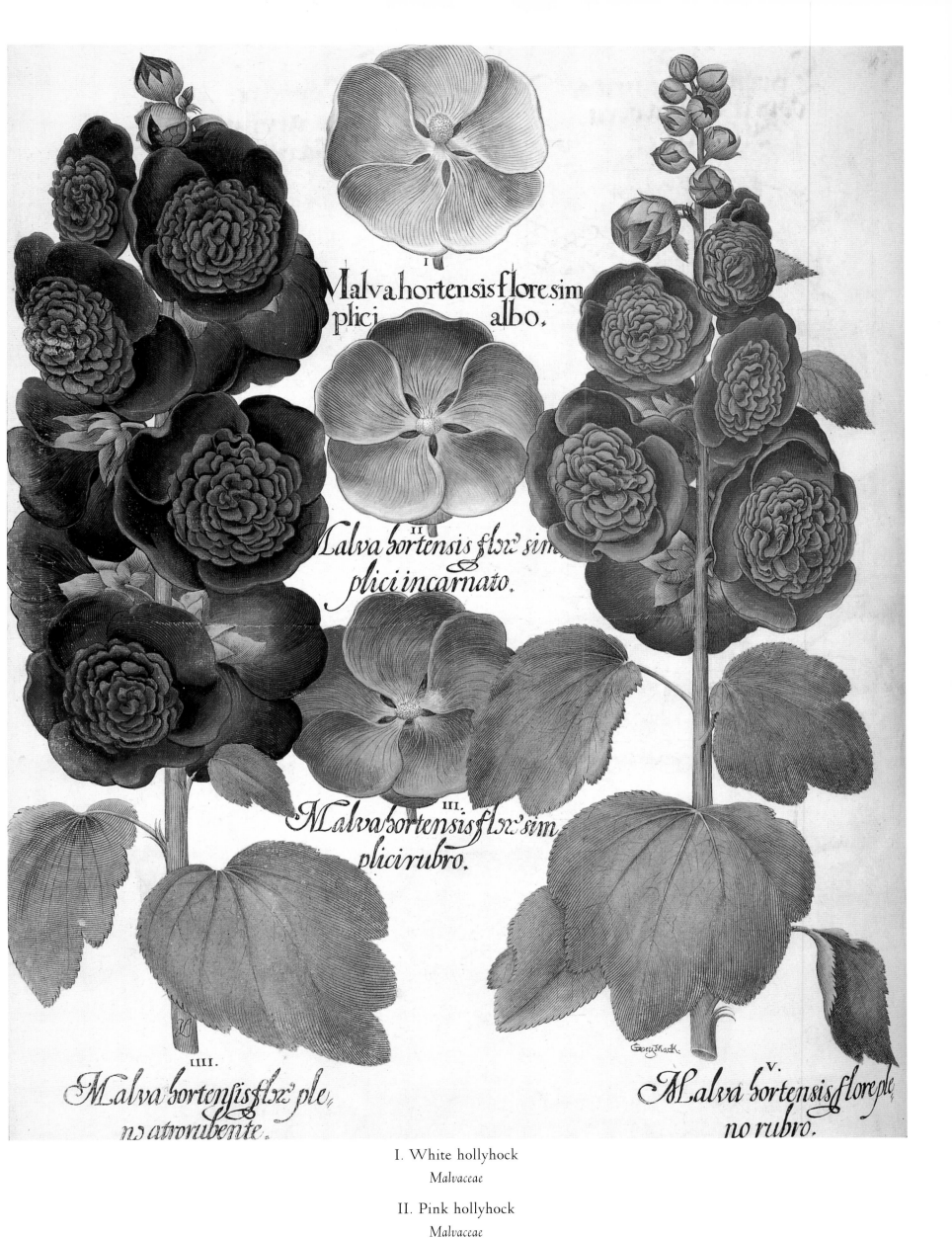

Malva hortensis flore sim
plici albo.

Malva hortensis flore sim
plici incarnato.

Malva hortensis flore sim
plici rubro.

Malva hortensis flore ple
no atrorubente.

Malva hortensis flore ple
no rubro.

I. White hollyhock

Malvaceae

II. Pink hollyhock

Malvaceae

IIII. Maroon double-flowered hollyhock III. Crimson hollyhock V. Crimson double-flowered hollyhock

Malvaceae *Malvaceae* *Malvaceae*

Plate 21

Introduced into Europe in 1596, this perennial plant, whose
root resembles a large, somewhat deformed turnip, has flowers
that are remarkable for their variability in size, color, and scent.
One of its popular names, marvel-of-Peru, attests to this
diversity. The other, four-o'clock, refers to the flowers' habit
of opening late in the day.

Many varieties of four-o'clock exist, some of them dense shrubs
whose flowers open at sunset or at night. Fifty or so species of
Mirabilis, all of American origin, have been recorded.

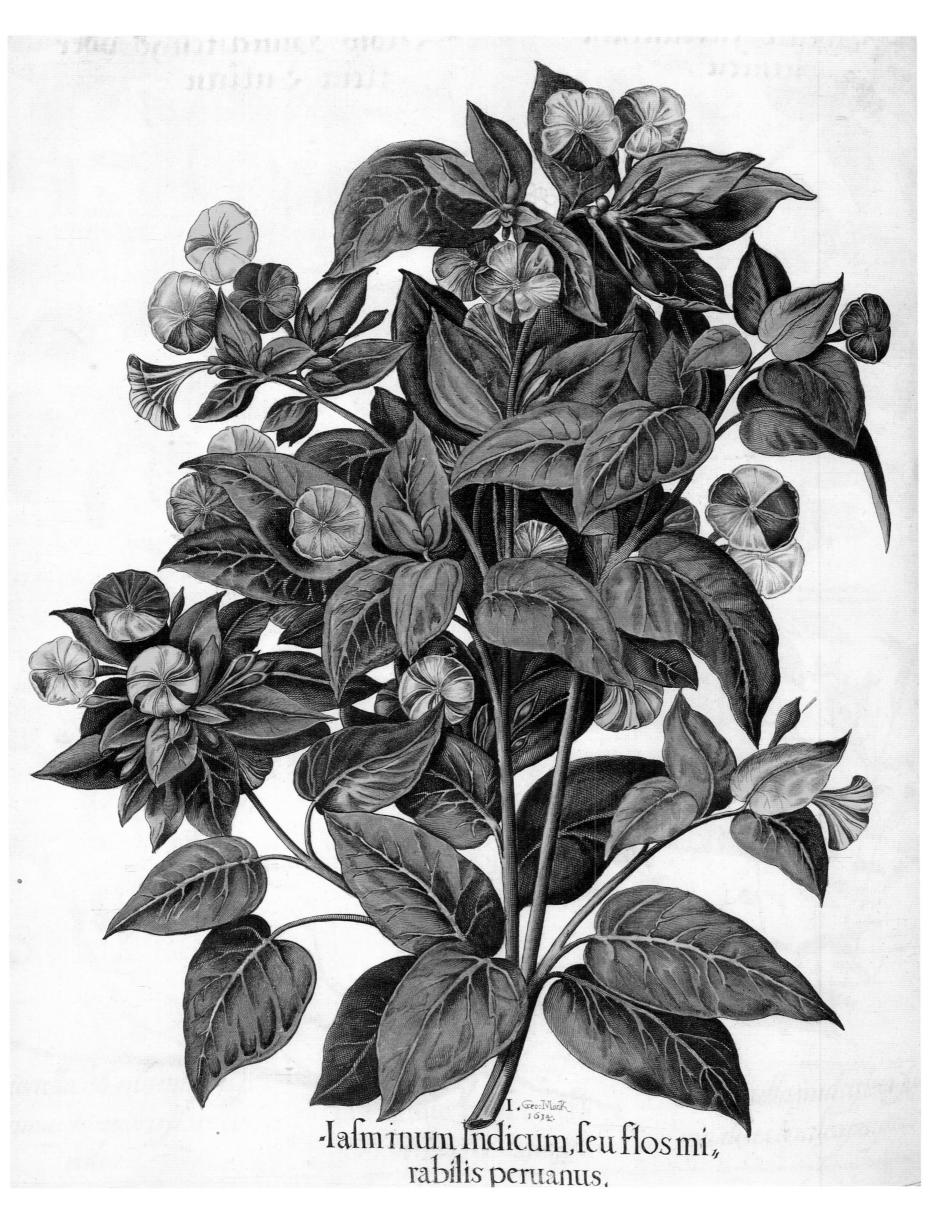

Iafminum Indicum, feu flos mi,
rabilis peruanus.

I. Variegated yellow four-o'clock

Nyctaginaceae

Plate 22

Among innumerable amaranth species, some of which are common garden plants, the unusual *Amaranthus tricolor* L., from tropical Asia, has long been recognized. Its amazing green, crimson, and deep yellow variegated foliage and inflorescences distinguish it from other amaranths. The names of some cultivars—'Combustion', 'Molten Fire', 'Illumination'—give an idea of the vivid color of this species. Amaranths are usually found in hot, humid climates.

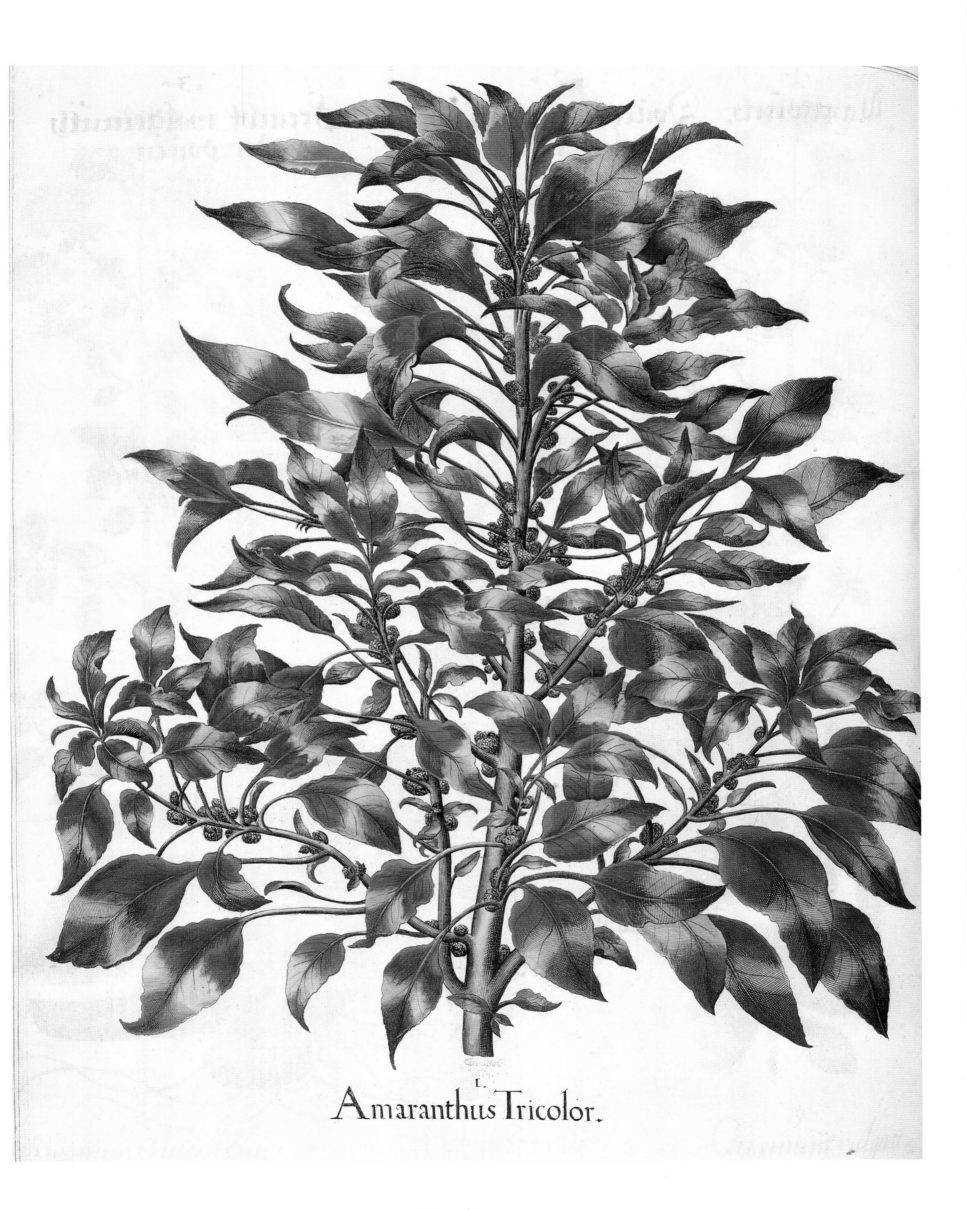

I.

Amaranthus Tricolor.

I. Joseph's-coat

Amaranthaceae

Plate 23

In comparing these autumn-flowering cyclamens, we are struck
by the differences between the plant shown in figure I (center)
and those seen in figures II and III (right and left). The plants
scarcely seem to be the same age. The central cyclamen has a
large flattened tuber. Its pointed leaves have a black marking
surrounding a central white area, and Besler describes it as
having ivy-like leaves.

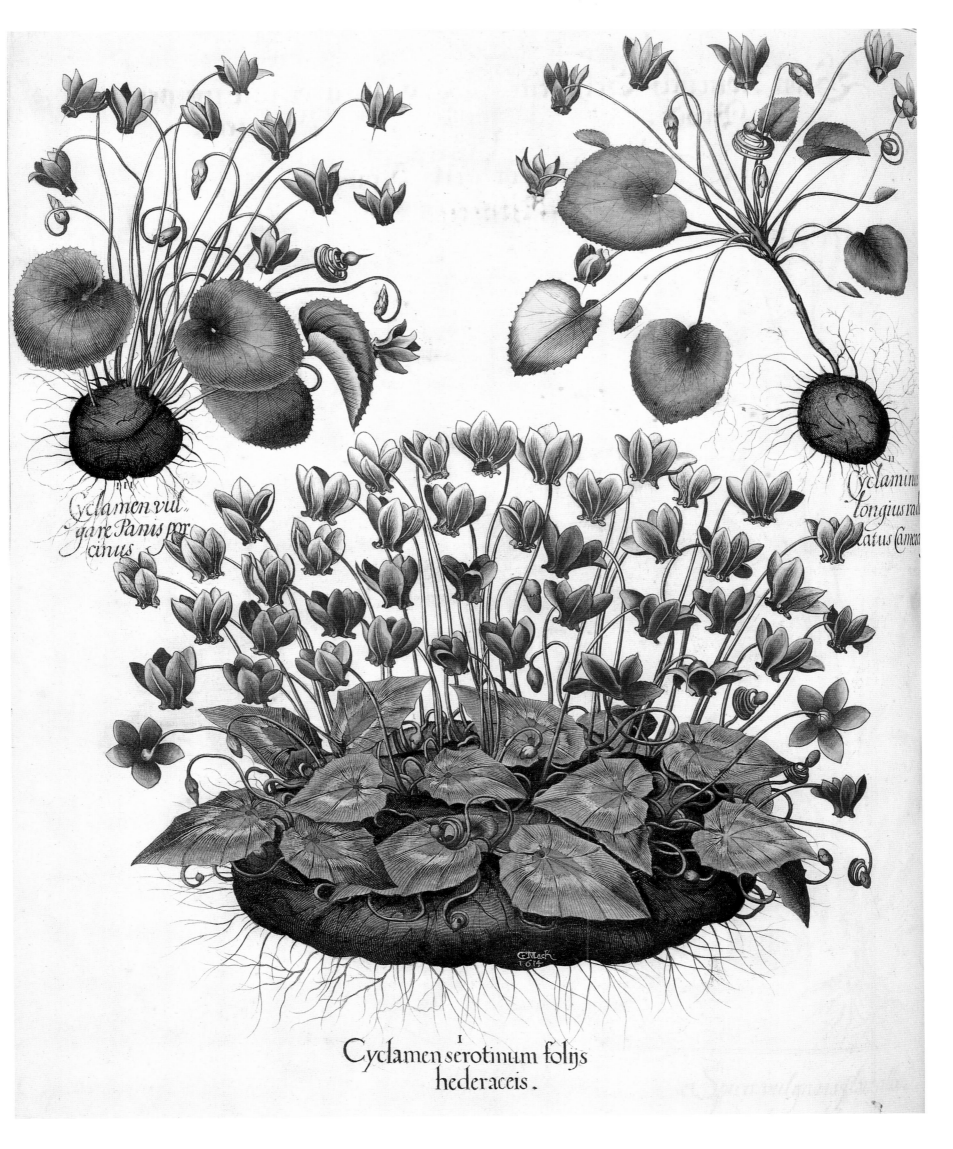

Cyclamen vul
gare Panis por
cinus

Cyclaminus
longius radi
catus Camea

I
Cyclamen serotinum folijs
hederaceis.

III. European cyclamen I. Ivy-cleaved cyclamen II. European cyclamen

Primulaceae *Primulaceae* *Primulaceae*

Plate 24

The plant shown here has spotted leaves, but it is nevertheless probably *Aloe vulgaris* LAMARCK, currently known as *Aloe vera* (L.) BURM. F. and not, as has been suggested, *Aloe variegata* L. The latter species, originating in South Africa, was undoubtedly not known in Europe in the late sixteenth century. Several hundred species of aloes exist. Most originated in tropical Africa but grow within an area extending from the Canary Islands to Cape Town and Madagascar. Some are found on the Arabian Peninsula, others as far east as India.

The aloe illustrated here is, according to Besler, "Aloe herbariorum," a plant with medicinal applications. Since antiquity, aloes have had many different pharmaceutical uses— as purgatives, laxatives, stimulants, and cicatrizants. Aloes were cultivated from the beginning of the seventeenth century as medicinal plants in the West Indies, and for this reason one of Aloe vera's common names is Barbados aloe.

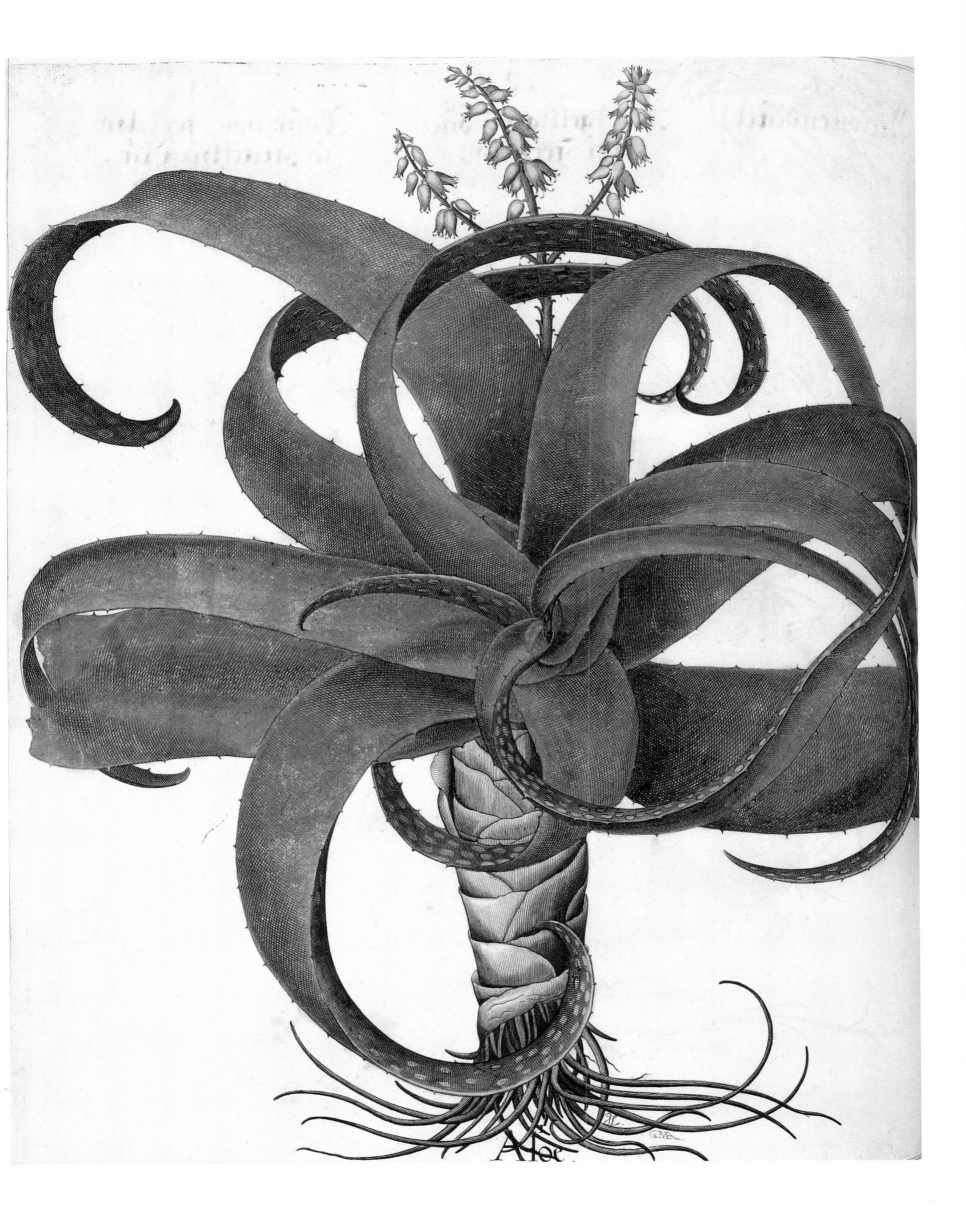

I. True aloe (Barbados aloe)

Liliaceae

Plate 25

The specimen seen here must be an early cultivated form of
Cynara scolymus, whose leaves were only slightly prickly at the
tip. This species was known in Naples, Venice, and Florence
in the seventeenth century and in England as early as 1550. The
large artichokes Besler obtained—in his texts he boasts of their
many fine qualities—would have been about eleven inches
in diameter.

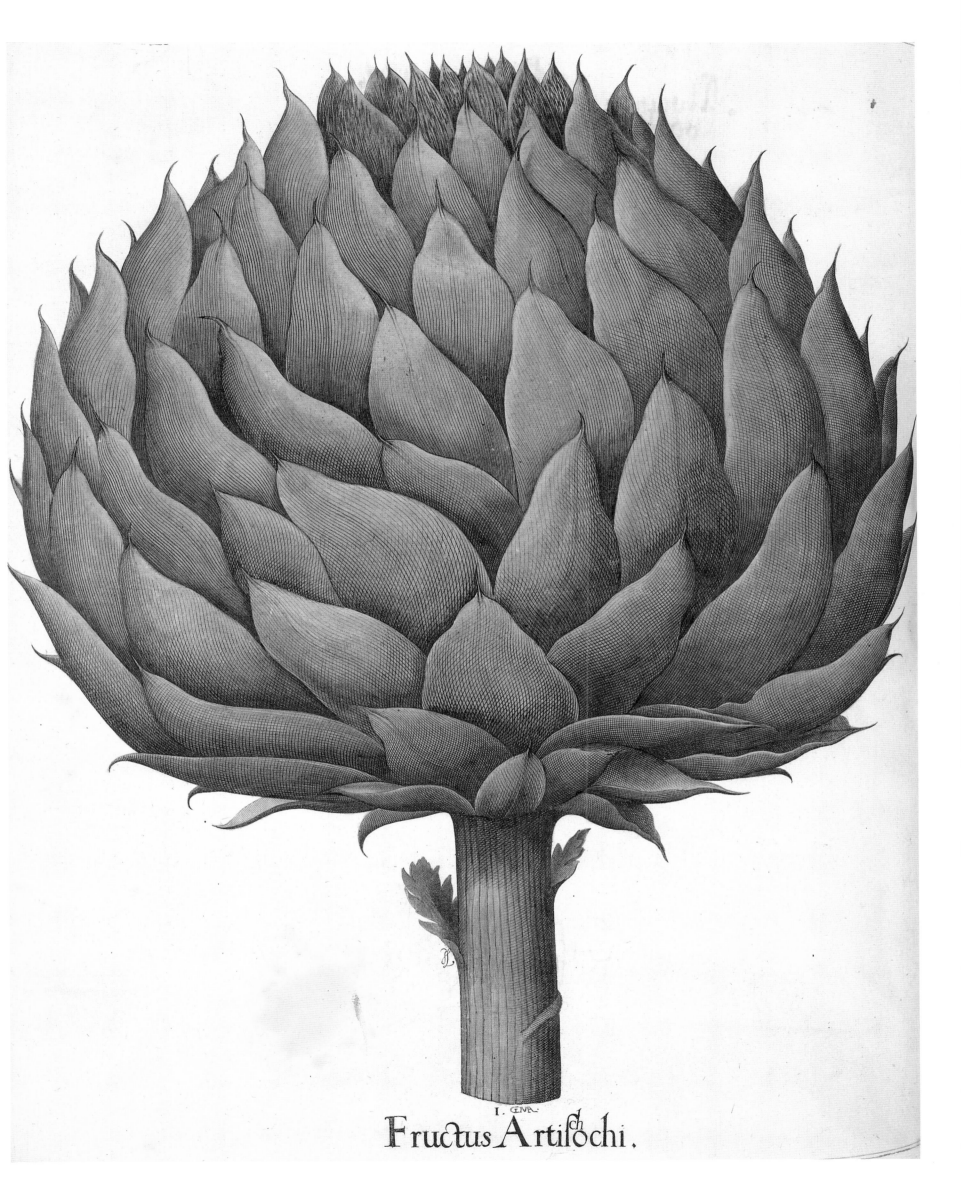

Fruꞇus Artiſochi.

I. Italian artichoke head

Compositae

Plate 26

The variegated iris of figure II (left) is very close to the
wild form of *Iris variegata* L. The flower in the center (I),
may also be the same hybrid. However, it has more in common
with *Iris pallida.* The yellow water flag, *Iris pseudacorus* L.
(III, right), is the most familiar plant on this plate. The water
flag grows wild throughout Europe and as far west as the
Himalayas. This species is probably the fleur-de-lis of the royal
coat of arms of France. The water flag appears in the most
ancient botanical books.

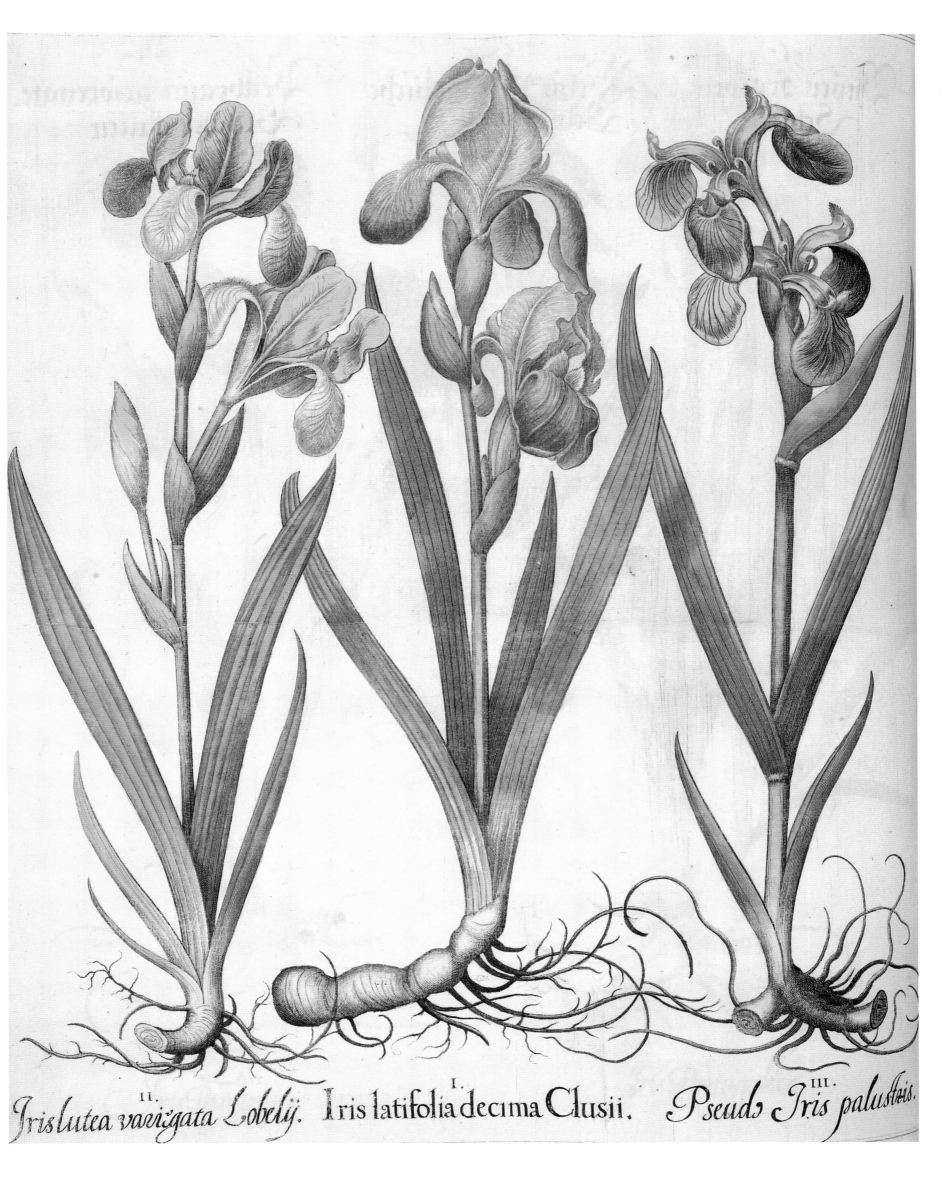

Iris lutea variegata Lobelij. *Iris latifolia decima Clusii.* *Pseudo Iris palustris.*

II. Variegated bearded iris

Iridaceae

I. Variegated bearded iris

Iridaceae

III. Water flag

Iridaceae

Plate 27

This plate illustrates several flowering plants of winter or early
spring, starting with the dark-foliaged little navelwort
Omphalodes verna MOENCH (I, center), with flowers of
a peerless blue.

The perennial *Adonis vernalis* L. (III, above left) bears magnifi-
cent, large golden flowers with a metallic cast. The leaves are
dark green and elegantly feathery. This species has medicinal
uses and has been dug up so much that it has become rare.

Besler's "Herba trinitatis" (IIII, below right) has nothing in
common with the hepaticas that were known by this name in
earlier botanical works. The plant illustrated here is a cultivated
form of *Viola tricolor* L.

Called *Primula veris* L., the cowslip (V, left) is one of the first
small flowers to brighten lawns at the end of winter and then
again in spring. Above right on this plate (II) is a single-
flowered plant of the species *Caltha palustris* L., also,
confusingly, called cowslip.

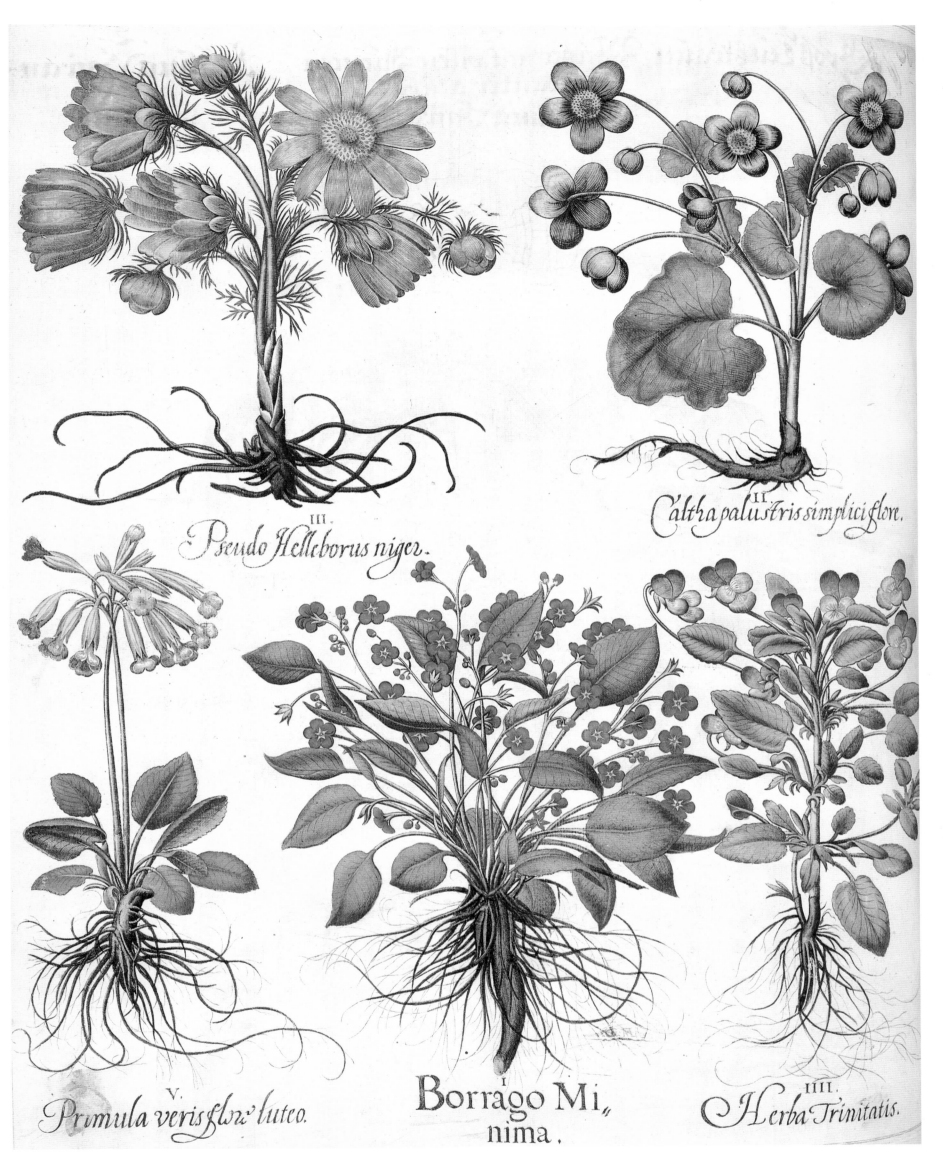

III.
Pseudo Helleborus niger.

II.
Caltha palustris simplici flore.

V.
Primula veris flor. luteo.

I.
Borrago Mi,,
nima.

IIII.
Herba Trinitatis.

III. Spring adonis

Ranunculaceae

II. Marsh marigold

Ranunculaceae

V. Cowslip

Primulaceae

I. Creeping forget-me-not (navelwort)

Boraginaceae

IIII. Garden pansy

Violaceae

LIST OF PLATES

Plate 1

I. Snowball viburnum

Caprifoliaceae

II. Garden broom

Leguminosae

III. Low-growing alpine broom

Leguminosae

Plate 2

I. Alpine currant

Saxifragaceae

II. Common currant

Saxifragaceae

III. Black currant

Saxifragaceae

IIII. Red currant

Saxifragaceae

V. White currant

Saxifragaceae

Plate 3

I. Late white tulip edged rose-pink

Liliaceae

II. Early bicolored tulip

Liliaceae

III. Early white tulip edged rose-pink

Liliaceae

IV. Late red and gold tulip

Liliaceae

V. Late red tulip with green stripes

Liliaceae

Plate 4

I. Poet's narcissus

Amaryllidaceae

II. Twin-flowered narcissus with orange-bordered yellow center

Amaryllidaceae

III. Twin-flowered narcissus with purple-bordered yellow center

Amaryllidaceae

Plate 5

I. Broken yellow *sylvestris*-type tulip

Liliaceae

II. Early crimson tulip edged white

Liliaceae

III. Silver-white tulip with blue and yellow halo

Liliaceae

IV. Tulip with tepals streaked white and crimson

Liliaceae

V. *Sylvestris*-type tulip tinged green

Liliaceae

Plate 6

I. Orange lily, mutation

Liliaceae

II. Pink lesser centaury

Gentianaceae

III. White lesser centaury

Gentianaceae

Plate 7

I. White rose of Sharon

Malvaceae

Plate 8

I. White double-flowered rose

Rosaceae

II. White rose

Rosaceae

III. Red *gallica* rose

Rosaceae

IV. White semidouble-flowered rose

Rosaceae

Plate 9

I. Large crimson corallina peony

Paeoniaceae

II. Common milkwort

Polygalaceae

III. Tufted milkwort

Polygalaceae

Plate 10

I. Silver-white dwarf bearded iris

Iridaceae

II. Purple dwarf bearded iris

Iridaceae

III. White dwarf bearded iris

Iridaceae

IV. Variegated dwarf bearded iris

Iridaceae

Plate 11

I. Purple English iris

Iridaceae

II. Blue Spanish iris

Iridaceae

III. Blue Spanish iris

Iridaceae

Plate 12

I. Seville orange

Rutaceae

II. Citron

Rutaceae

III. Orange

Rutaceae

Plate 13

I. Double-flowered pomegranate

Punicaceae

II. Cherry plum

Rosaceae

III. Apricot

Rosaceae

Plate 14

I. White foxglove

Scrophulariaceae

II. Common pink foxglove

Scrophulariaceae

III. Orange hawkweed

Compositae

Plate 15

I., II. Scarlet turk's-cap lily (Chalcedon lily) and bulb

Liliaceae

III. Autumn squill

Liliaceae

Plate 16

I. Common sunflower

Compositae

Plate 17

I. Daisy

Compositae

II. Yellow crown daisy

Compositae

III. Wild crown daisy

Compositae

Plate 18

I., II. Basils

Labiatae

Plate 19

I. Red peppers with long, pendant fruit

Solanaceae

II. Red peppers with long, pendant fruit

Solanaceae

Plate 20

I. White hollyhock

Malvaceae

II. Pink hollyhock

Malvaceae

III. Crimson hollyhock

Malvaceae

IIII. Maroon double-flowered hollyhock

Malvaceae

V. Crimson double-flowered hollyhock

Malvaceae

Plate 21

I. Variegated yellow four-o'clock

Nyctaginaceae

Plate 22

I. Joseph's-coat

Amaranthaceae

Plate 23

I. Ivy-cleaved cyclamen

Primulaceae

II. European cyclamen

Primulaceae

III. European cyclamen

Primulaceae

Plate 24

I. True aloe (Barbados aloe)

Liliaceae

Plate 25

I. Italian artichoke head

Compositae

Plate 26

I. Variegated bearded iris

Iridaceae

II. Variegated bearded iris

Iridaceae

III. Water flag

Iridaceae

Plate 27

I. Creeping forget-me-not (navelwort)

Boraginaceae

II. Marsh marigold

Ranunculaceae

III. Spring adonis

Ranunculaceae

IIII. Garden pansy

Violaceae

V. Cowslip

Primulaceae